GLOUCESTER MASSACHUSETTS

ROCKPORT PUBLISHERS

Web Tricks and Techniques: Interactive Pages with Flash

Fast Solutions for Hands-On Web Design

DANIEL DONNELLY

First published in the United States of America by:
Rockport Publishers, Inc.
33 Commercial Street
Gloucester, Massachusetts 01930-5089
Telephone: (978) 282-9590
Fax: (978) 283-2742
www.rockpub.com

ISBN: 1-56496-945-2 (paperback)

Printed in China

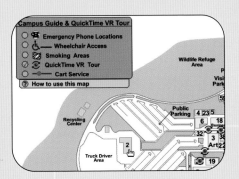

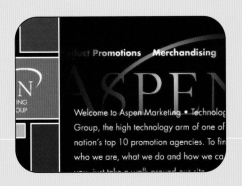

I would like to thank the following people for their assistance:

Jesse Hall for his help in deciphering all of the great projects featured in this book.

Carolyn Short for her work in creating the Butte College Flash map and then helping to write the map tutorial.

Marcus Gindroz and Marc Boyett from MSP12 for their help in testing the tutorials.

Editor Don Fluckinger for all of his great work.

Winnie Prentiss and Kristin Ellison for their patience over the past few years.

This book is dedicated to Jeannie for all she does to keep me focused and on track.

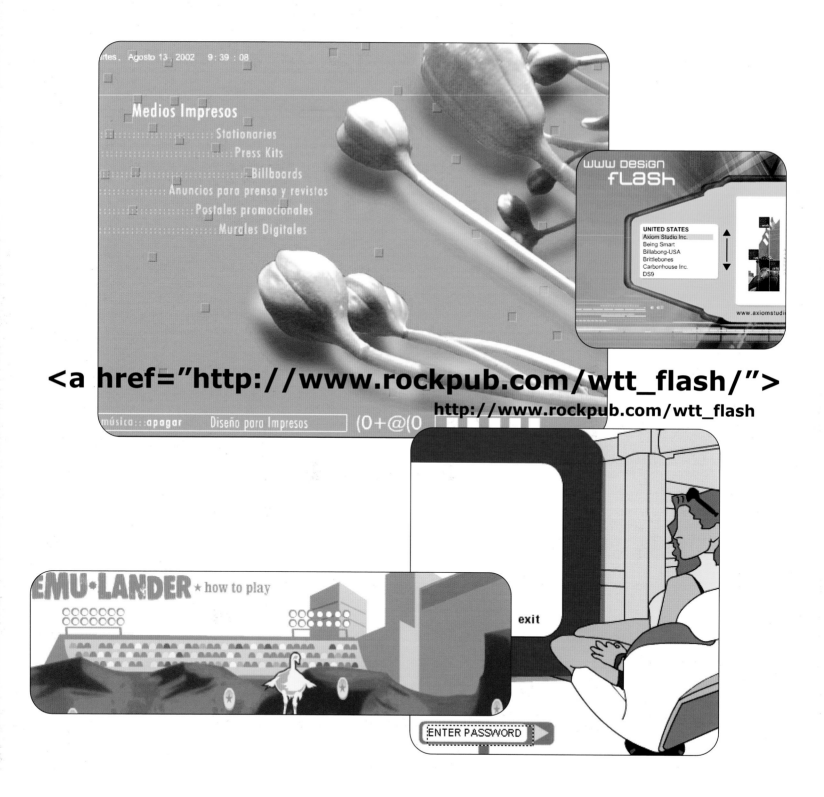

http://www.rockpub.com/wtt_flash

< Contents >

< **Introduction** >

In the past two years, Flash has become one of the most widely used software applications in the design industry for creating animated and interactive Web sites. There are thousands of new Web sites popping up every day that showcase this technology. There are also a lot of poorly designed sites both within and outside of the design industry. The links showcased in the Resources section are a collection of some of the best tutorial, book, reference, animation, and design studio Flash sites that have been collected.

The list is growing constantly and as current sites grow old and die or fade away into obscurity, several new sites are there to take their places. As such, the links on these pages may not always be around. Check out the Web Tricks and Techniques Web site (www.rockpub.com/wtt_flash) for updates to these pages.

Animation

The Cotaco changing backgrounds tutorial illustrates how to create an animated button that allows a user to switch between two different background scenes within an interface.The moving sun that glides slowly across the screen is a button that when clicked changes the screen's background image from day into night.

~

The Aspen Marketing tutorial shows how to create scrolling text that blurs the type at the edges as the text scrolls in and out of a defined area in a text block, giving the illusion of text disappearing at the edges. Two examples are shown: a fade created directly in Flash, and an exported Adobe Photoshop PNG.

~

The Cotaco cursor trail tutorial features a simulated cursor trail used in select screens of the comapny's portfolio. This tutorial removes the need for advanced ActionScript programming and accomplishes all of the animation through tweening and button rollovers. This tutorial showcases an easy and quick way to create a cursor trail with this technique.

are left behind for more organic imagery. The smooth, rounded, and textured images of natural objects can enhance a design in many ways, and can be useful for capturing a user's attention.

The Cotaco Web site showcases the design firm's work using bright, colorful imagery of natural objects; plants and flowers offer visitors to the site an organic experience. The moving sun that glides slowly across the screen is a button that, when clicked, changes the screen's background image from day into night.

This tutorial shows how to create an animated button that allows a user to switch between two different backgrounds within an interface. To complete this tutorial, the reader should know how to work with toolbox tools and modifiers, symbols and instances, the timeline and frame labels.

Cotaco Studio Portfolio

Project	Cotaco Studio Portfolio
Design Firm	Cotaco Studio
Design	Carmen Olmo
Scripting	Carmen Olmo
Production	Carmen Olmo, Carmen C
Software	Macromedia Dreamweav
	Adobe Photoshop, Cool
Country	Puerto Rico
URL	www.cotaco.com

1

Using a Mask to Create Depth

Masking elements in Flash can be used to create many different effects. In this project, a mask creates an illusion of the sun and moon passing beneath the flowers.

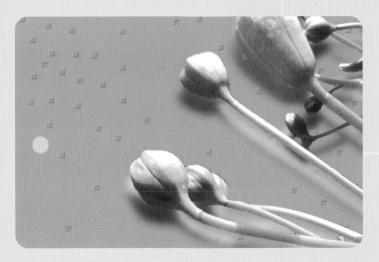

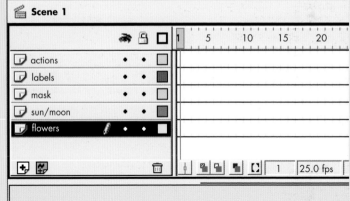

The first step to creating a project similar to this is to open a new file and change the properties of the movie. Use the *Command-M* or *Control-M* keys to quickly open the Movie Properties dialog box. The movie size is 727 pixels wide by 390 pixels in height.

Set the Frame Rate to 25. A high frame rate will give the project smoother movement as it plays in a Web browser.

Set the background color by clicking on the color chip and selecting a dark gray from the color palette.

Next, create five layers and name them from top to bottom; "actions," "labels," "mask," "sun/moon," and "flowers."

The large background image of the flowers is a JPEG graphic exported from Adobe Photo-shop and imported into Flash.

The image used in this project is 727 pixels wide by 390 pixels in height. The full image incorporates the flowers, a gray background, and the small embossed squares that create a pattern at the left side of the screen. The next step will be to import the JPEG.

Compressing JPEG Graphics

JPEG graphics can be optimized before bringing them into Flash, but they also can be compressed and optimized within Flash. Open the Library on a project and double-click a JPEG graphic. This will open the Bitmap Properties window for the specific graphic.

Uncheck the "Use imported JPEG data" checkbox. This shows the Quality adjustment field. Change the quality and click the Test button on the right side of the window to see how much K size can be reduced by optimizing in this way.

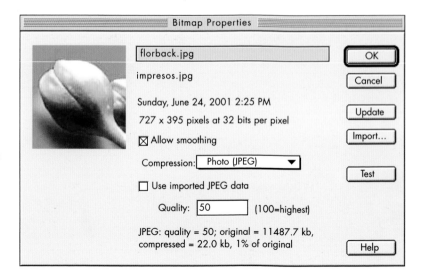

2

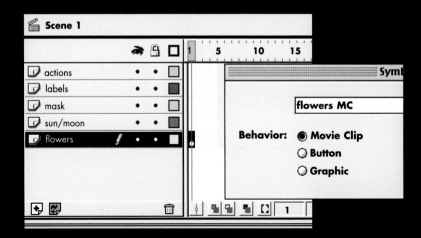

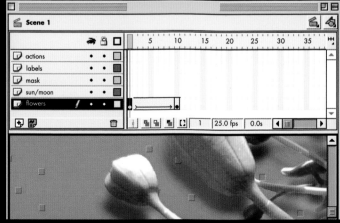

Once the movie properties have been set, select the first frame in the "flowers" layer and import the 727 by 390 pixel JPEG that will be used for the background by using *Command-R*.

Select the JPEG graphic that was just imported and press the *F8* key to bring up the Symbol Properties dialog box. Make sure Movie Clip Behavior is selected and name the symbol "flowers MC."

The next step is to fade in the new "flowers MC" movie clip that was just created. Select frame 10 in the "flowers" channel and insert a Key frame by hitting the *F6* key. Select the first Key frame by clicking on the black Key frame dot in frame 1. With this Key frame selected, choose

Insert->Create Motion Tween. An arrow will appear showing that an effect or animation can be added to this set of frames.

Choose *Window->Panels-> Effect* and choose *Alpha* from the pull-down menu.

Tint or Alpha?

If a graphic is on a flat color background, such as gray, and needs to be faded away to make it disappear, it may be better to use the Tint effect rather than the Alpha to save processing power and memory.

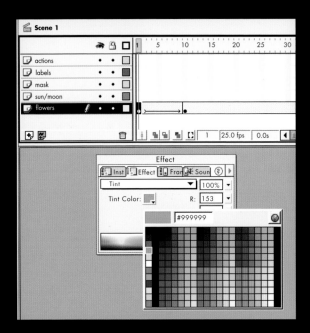

3

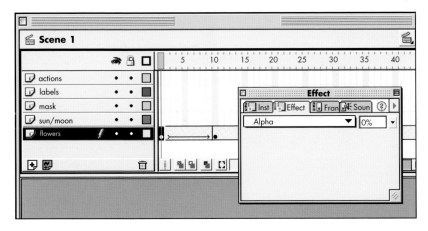

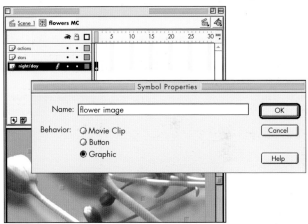

Change the Alpha to 0 percent. Setting the beginning key frame to 0 percent Alpha and the ending key frame to 100 percent Alpha will create an animated fade between the two key frames. A tint of the same gray used for the background would also work for this fading animation (see note above), but for this

example, the designer chose to use Alpha rather than Tint to adjust the transparency of the image.

Select the frame 10 key frame and choose *Edit->Edit Symbols* to enter the editing mode for the "flowers MC" movie clip.

Rename "Layer 1" to "night/day," and then create two more layers. Name these layers from top to bottom, "actions" and "stars." Select the key frame in frame 1

of the "night/day" layer and press the *F8* key to bring up the Symbol Properties dialog box. Name the symbol "flower image" and select Graphic as the symbol Behavior.

Inserting New Key Frames in an Existing Motion Tween

There are two ways to insert a new key frame within a tweened series of frames. While pressing the Command key (Mac) or Control key (Windows), click in a specific frame between two motion tweened key frames. This selects just the single frame clicked on.

The second way to insert a new key frame is to select the working layer and position the playhead over a specific frame, press the *F6* key to insert a new key frame.

4

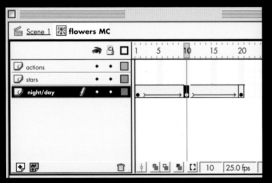
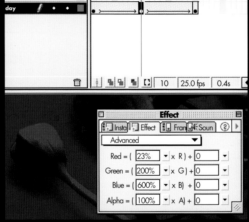
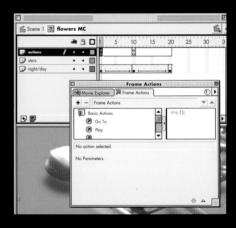

Select the key frame in the first frame of the "night/day" layer and choose *Insert->Create Motion Tween*. Select frame 20 in the same layer and insert a key frame using the *F6* key.

Next, position the playhead over frame 10 and be sure the night/day layer is selected. Press the *F6* key to insert a new key frame in frame 10.

Choose *Window->Panels-> Effects* to open the Effect panel.

Choose the pull-down menu and select Advanced. Change the red to 23 percent, green to 29 percent, and blue to 69 percent. This action tints the graphic symbol to a shade of blue that resembles an evening sky. The graphic fades from normal to blue and back to normal.

Next, select the "actions" layer and double-click in the first frame to bring up the Frame Actions window. Choose *(+)->Basic Actions->Stop*. Copy this frame using *Edit->Copy Frames*. Select frame 10 in the "actions" layer and choose *Edit->Paste Frames*.

Creating the Animated Stars

1. Insert a key frame–*F6*–in frame 10 of the "stars" layer. Select the Oval Tool from the toolbar and draw a circle 9 pixels in diameter. Use the Shift key when drawing to constrain the circle to a perfect circle. Use the Info panel, *Window->Panels->Info* to change the width and height of the circle to exactly 9 pixels.

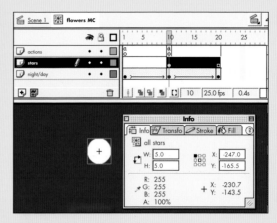

2. Select the circle on the Stage and convert to symbol by pressing the *F8* key. Select Movie Clip, name the symbol "all stars," and click OK. Press the *Command-E* keys to enter the editing mode for this movie clip symbol.

3. Select the circle again on the Stage and convert to a graphic symbol. Name the symbol "star" and click OK.

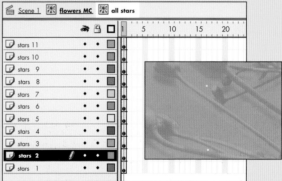

4. Insert and name the ten additional layers as shown at right. Copy the first key frame star. Select each layer, then paste and move the star to a random spot on the Stage. Next, select the first key frame in all eleven layers and choose *Insert->Create Motion Tween*. Select frame 15 on all layers and insert a key frame to connect the motion tween. Position the playhead over frame 6, select the first layer and press the *Command-A* keys to select all layers. Press the *F6* key to insert a new key frame in all layers. Position the playhead over frame 10 and select all frames once again, then insert a new key frame across all layers.

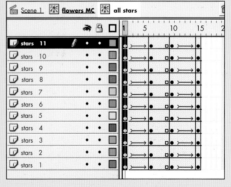

5. Select the first of the "stars 11" layer and press the *Command-Option-S* keys to bring up the Scale and Rotate dialog box. Type in 56 percent to reduce the circle to 5 pixels in diameter. Select frame 16 in the same layer and repeat this operation. Select the first and fifteenth frames in each of the eleven layers and repeat this operation until all stars have been scaled.

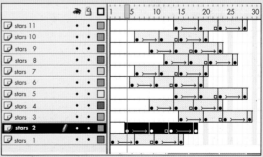

6. While pressing the Command key, click in frame 6 of the stars layer 11 and drag down until all single key frames are selected. Choose *Window->Panels->Frame* and change the Tweening to None.

7. The final step is to select all frames in "stars 2" layer by clicking on the layer icon at the left of each layer name. Grab the frames and offset them by dragging and repositioning the full set of frames as shown at right.

Working with Labels

Select a frame in the main Timeline and open the Frame panel. Type a name in the Label field. The label will be shown in the Timeline as a red flag. Depending on the number of the frames in a row, the name of the label will show in the frame layer. If the frames for the label are only one or two frames in length, only the red flag will show.

A label can be used in a frame to send the playhead directly to a label with scripting. A simple script of `gotoAndPlay {"loop"};` will send the playhead on the Timeline directly to the "loop" label.

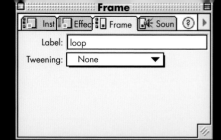

5

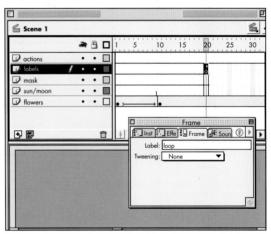

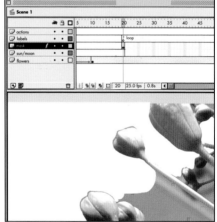

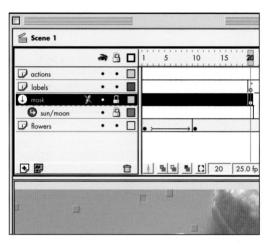

Return to the main scene Timeline and select frame 20 in the "labels," "mask," and "sun/moon" layers. Insert key frames, *F6*. Select frame 20 in the "labels" layer and choose *Window->Panels->Frame*. Type "loop" in the Label field.

Next, select frame 20 in the mask layer. Select the Brush Tool from the toolbar and paint a white mask area. The flower image will be masked wherever there is white, allowing the traveling sun/moon object to pass beneath the solid flower image.

Move the cursor over the "mask" layer and hold down the *Control* key to bring up the Mask selection menu. Choose Mask and release the menu. This transforms the "mask" layer with the white area graphic into a Mask layer and the "sun/moon" layer into a Masked layer. Notice the white circle with

an arrow pointing down indicating a Mask layer. The purple circle with a white arrow shows the Masked layer directly beneath. Both layers are automatically locked when made into Mask and Masked layers.

The Playhead Scrubber

Often, the fastest way to view an animation in the Timeline is to grab the red playhead icon on the Timeline's frame bar and drag it back and forth. This is known as "scrubbing."

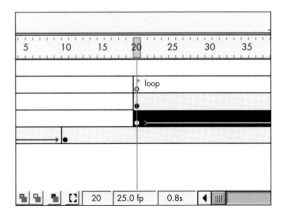

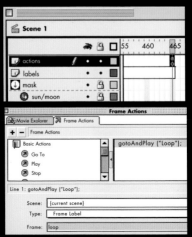

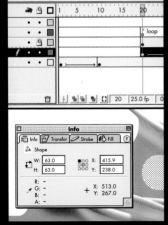

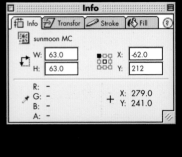

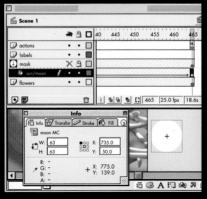

6

Scroll the Timeline to frame 465 and double-click frame 465 in the "actions" layer to bring up the Frame Actions window.

Choose (+)->*Basic Actions*->*Go To*. Use the Type pull-down menu to select Frame Label and type "loop" in the Frame input field. Scroll back to the beginning of

the Timeline and select frame 20 in the "sun/moon" layer.

Select the Oval Tool from the toolbar and draw a circle 63 pixels in diameter. Use the Info panel to constrain the circle's size by changing the width and height to 63 pixels.

Select the circle and choose *Insert->Convert to Symbol*. Select Movie Clip and name it "sun/moon MC." Click OK.

Position the "sun/moon MC" movie clip off the left edge of the Stage using the Info Panel's x and y positioning; -62 x and 212 y.

With frame 20 of the "sun/moon" layer selected, choose Insert . Create Motion Tween. Scroll to frame 465 and insert a new key frame in the same layer. Position the "sun/moon MC" at 735 x and 50 y to place the movie clip off the right side of the Stage.

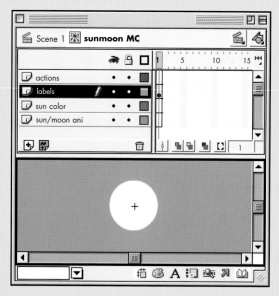

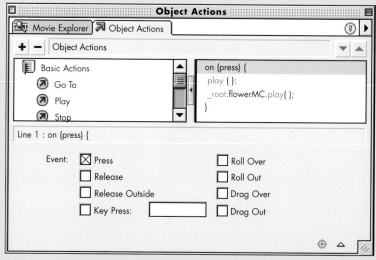

7

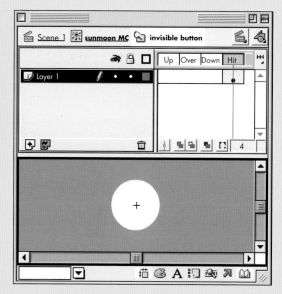

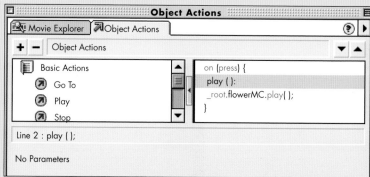

Next, enter the editing mode for the "sun moon" movie clip by pressing the *Command-E* keys. Rename "layer 1" to "button" and add three additional layers. Place one layer above the "button" layer and name it "actions."

Place two layers below "button" and name them "sun color" and "sun/moon ani" as shown above left.

Select the circle and press *F8* to bring up the Symbol Properties. Select Button as the symbol and name it "invisible button."

Double-click the circle to open the button edit window. Click on the key frame in the Up state and drag it over into the Hit state frame. Placing a key frame only in the Hit state of an object makes the button invisible.

Return to the "sunmoon MC" Timeline and select the button once again. Choose *Window->Actions* to open the Actions window. Select *(+)->Basic Actions->On Mouse Event*.

Creating the Frame-by-Frame Moon Animation

To create the animated waning of the moon—morphing from full to a sliver—the designers chose to use frame-by-frame animation. Twenty frames were used to create the full animation.

To create a frame-by-frame animation, select the first frame of the animation and insert a key frame *(F6)*; this duplicates the previous frame into the next frame. Adjust the new key frame by making it a little less rounded and then duplicate this key frame by pressing *F6*. Continue this process until the object is in the final stage of the animation.

Scrub the playhead back and forth while creating the animation to make sure that it looks they way it should.

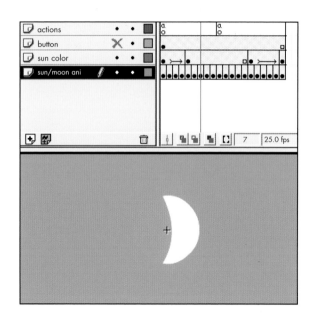

8

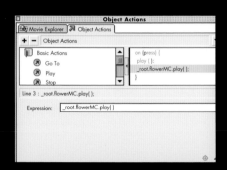

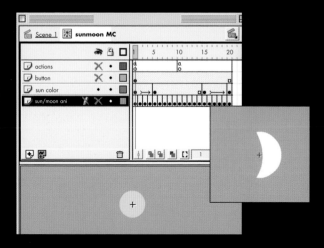

Next, choose *(+)->Basic Actions ->Play*, and then *(+)->Actions->Evaluate*. In the Expression field type _root.flowerMC.play(). The full script should read:
```
on (press) {
  play ();
  _root.flowerMC.play();
}
```

Select frame 20 in the "button" layer and insert frames using the F5 key. Select frame 1 of the "actions" layer and add a *Stop action*. Copy the Stop action and Paste it in frame 10. Hide the "button" layer and select frame 1 of the "sun color" layer. Draw a yellow circle 41 pixels in diameter. Select the circle and convert

it to a graphic symbol, *F8*. Name it "sun." Select frame 1 and choose *Insert->Create Motion Tween*. Insert a key frame at frames 5, 15, and 20. Select frames 5 and 15 and change the Alpha to 0 percent. This fades the sun color. Hide this layer. Select the "sun/moon ani" layer and create a frame-by-frame animation

of a moon 41 pixels in diameter. The shape switches from full to a three-quarter slice and back to full. Set registration to 0 x and 0 y. (See preceding steps.)

Return to the main Timeline and test the movie.

< Animation: Scrolling Text Fade >

Flash offers a wide variety of animation features that can be applied to text, from simple tweening across a Stage, to frame-by-frame animation and more complicated techniques, such as scrolling large amounts of text in text boxes, or using masks to add fades.

The Aspen Marketing Technology Group Web site, designed by Ryan Nielson, uses masks for scrolling and fading text. The contents page is the main Flash file and all other pages open from the colorful rectangles as either Flash windows or HTML pop-up windows via JavaScript code.

This tutorial shows how to create scrolling text that blurs at its edges as it scrolls in and out of a defined area in a text block, giving the illusion of text disappearing at the edges. Two examples are shown: a fade created directly in Flash and an exported Adobe Photoshop PNG. To complete this tutorial the reader should know how to work with drawing tools, buttons and symbols, tweening, the library, and Adobe Photoshop.

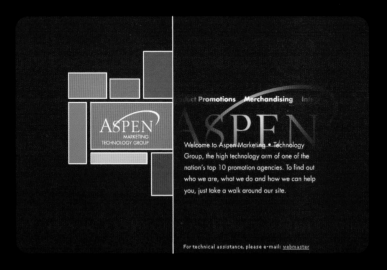

Aspen Marketing Technology Group

Project Group Web Site (Boise office)
Design Firm . . . Aspen marketing Services
Design Annette Bush
Scripting Ryan Nielson
Production . . . Kelly Shepard, Tim Nichols, Annette
. Bush, Chad Brusse, Kurt Olson,
. Rene Mifflin
Photography . . Agency Digital Photos
Software Adobe Photoshop, Adobe Illustrator
Country U.S.A
URL www.mindspring.com/~rniel/amtgsite

1 Animating Text

Animated text is one of the easiest Flash elements to learn. Using tweening to animate an object moving across the Stage can be learned in a matter of minutes. Once the basics of animating text are learned, designers begin to realize that there are many other ways to create animated text using multiple layers, masks, scripting, and also incorporating other design programs such as Adobe Photoshop or Illustrator.

The first part of this Aspen Marketing Group project tutorial shows how to create the scrolling text fade using only the Flash tools. The second part focuses on incorporating an external application to create the graphic text element in the Aspen Marketing Group project.

In the second part of the tutorial, the designer uses Adobe Photoshop to create and export a transparent .png file, then imports the file into Flash.

Step 1: With Flash open, create a new movie, *File->New*. The movie can be any size. (This project describes how the scrolling text fade was implemented in the original Aspen project.) The Aspen Marketing Group project movie file size is 760 by 450. The background hex color is #330066.

New movies open with a default "Layer 1" name. Rename the layer to "bgrnd art" and draw an interface that will incorporate the scrolling text fade.

Next, create a second layer by clicking the new layer (+) icon at the bottom of the layers window.

Planning and Storyboarding

Many designers straight out of school believe they are capable of going directly to the computer for the design stages of a project without first having to draw and sketch their ideas on paper. For some this may actually work, but the majority of professional designers know that a lot of time can be wasted if the project is not fully thought out before heading to the computer.

In order to know where the scrolling text would go in the final Aspen Marketing project, the designer needed to do concept sketches to plan for the text to look as if it is appearing from within the logo's swoosh and then disappearing at the edge of the left-hand graphic.

Though seemingly simple, this element required forethought and planning to accomplish and adds to the professional look and design of the project.

2

Rename the new top layer "mcscroll." This will be where the single movie clip for this project will be placed.

Choose *Insert->New Symbol* from the menu, select Movie Clip as the symbol and name the movie clip "MCscrolling text." Click OK. An empty movie clip edit window appears with the same color background as the main Stage.

Rename the "Layer 1" layer "text 2" and create three additional layers. Name these layers, from bottom to top, "text 2," "mask layer," and "gradient graphic." Each layer is created with a default blank key frame located in the first frame.

Choose *Modify->Movie* from the menu and choose a dark gray color from the color palette. (This allows the green guidelines to be seen on the editing window.) Choose *View->Rulers* from the menu.

3

Click in the vertical ruler and drag out guides 150 pixels left of the 0 mark and 150 pixels right of the 0 mark. Click in the horizontal ruler and drag a guide to 10 pixels above the vertical 0 mark and another guide 10 pixels below the 0 mark.

Click once on the "gradient graphic" layer to highlight the layer. In the toolbar, select the Rectangle Tool. Select the Stroke Color (the top color chip on the toolbar, and then select the red slash mark at the far right of the color palette to turn off the Stroke Color.

Using the Fill Color chip just below the Stroke Color, select the color used for the original Stage, #330066. These steps set the box that will be drawn to have no stroke and a specific solid-color fill when drawn.

Draw a box within the guides as shown above.

Before the solid color box can be turned into a gradient, it must first be made into a Graphic Symbol.

Select the graphic with the Arrow Tool and choose *Insert->Convert to Symbol* from the menu. Choose *Graphic* as the symbol and name it "gradient graphic."

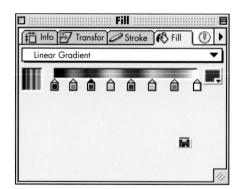

Fill Panel Gradients

The Fill panel offers two different gradient formats, Linear and Radial. Eight different colors can be added to each gradient by clicking just below the gradient bar.

Designers using gradients should limit the use of this technique. Color increases a Flash project's size, and using too many gradients can increase the file size tremendously.

4

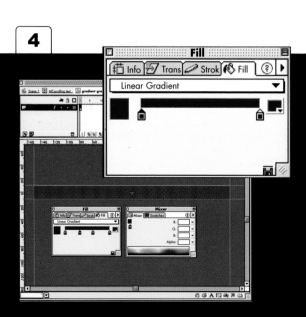

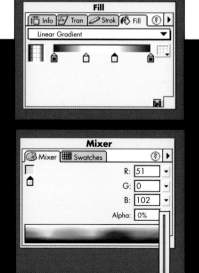

The next step is to change the box's solid fill to a gradient fill using the Linear Gradient option on the Fill panel.

Double-click the solid color box to open up the Graphic Symbol for editing. (Notice the texture the box has when selected.)

Choose *Window->Panels->Fill* from the menu. In the Fill panel pull-down menu, choose Linear Gradient. Two color chip arrows appear on each side of the panel's gradient color bar. When an arrow has a black top, it is showing the color chosen for the specific arrow.

Click twice in the middle of the Fill panel's Linear Gradient bar to create new gradient color arrows. With the cursor, slide each of the arrows apart as shown above.

The space between the two new arrows will be the transparent area

of the color bar.

Choose *Window->Panels->Mixer* to bring up the Mixer panel. Change the Alpha (transparency) of each gradient arrow. Click on the left middle gradient arrow and in the Mixer panel drag the Alpha slider bar to zero percent (0%). Do the same for the right middle arrow.

Breaking Apart Text

Text does not have to be broken apart in Flash, but there are instances where it could be helpful, such as in the project below. There are two lines of text used in the project. The first was created using the Text Tool and typing out the list of product links needed for the site. The second text file is a duplicated symbol of the first.

Modify->Break Apart is used on both text files because the designer did not want any chance of the list being modified as he aligned them next to each other. Another reason is that the first list is the whole list of links. The duplicated list has been cut away so it is only a partial list showing the last ending words of the full list.

The lists align with each other in such a way that, as one list approaches the end of its line in the scrolling animation, the other list begins to animate and gives the illusion of a continuously scrolling line of text links.

5

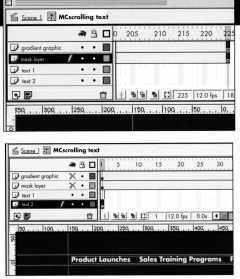

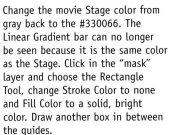

Change the movie Stage color from gray back to the #330066. The Linear Gradient bar can no longer be seen because it is the same color as the Stage. Click in the "mask" layer and choose the Rectangle Tool, change Stroke Color to none and Fill Color to a solid, bright color. Draw another box in between the guides.

Next, scroll the Timeline to approximately frame 225. Select frame 225 in the "gradient graphic" and "mask layer" and choose *Insert->Frames* to fill all frames between frame 1 and frame 225.

Scroll back to frame 1 in the Timeline and click in the "text 2" layer to highlight frame 1.

Use the Text Tool to create a line of text for the scrolling links (see description above). Select the text with the Arrow Tool and choose *Modify->Break Apart*, and then *Insert->Convert to Symbol*, from the menu. Select Graphic as the symbol and name it "text 2."

Open the Library, *Window->Library*, and duplicate the "text 2" graphic symbol by using the Library option's pull-down menu located at the top of the palette. Double-click the duplicated symbol name and rename it "text 1."

Tweening Animation

Motion tweening and Shape tweening are the two types of tweened animation that can be created in Flash. Both use a beginning and ending key frame with a sequence of in-between frames automatically created incrementally between the two key frames.

Motion tweening is used to animate a multipart object, such as text or a character moving across a Stage. Shape tweening is used to change an object, such as transforming a box into a sphere.

The main distinction between the two is that a Shape tween can only be applied to an editable object and a Motion tween can be applied to groups and symbols.

6

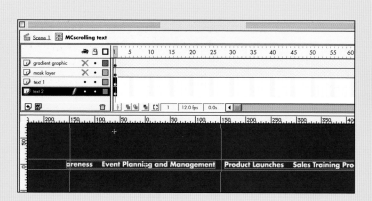

Click on the "text 1" layer. In the Library window, drag the "text 1" symbol on to the editing area. Delete all words but the ending "areness Event Planning and Management."

Turn off the top two layers to avoid confusion when working with the text layers.

Align the "text 1" text with the same baseline as the "text 2" text, and place it between the guide lines as shown.

Click on the key frame in frame 1 of the "text 1" layer and drag it to frame 225. This will help to align "text 1" and "text 2."

Click in frame 225 in the "text 2" layer and choose *Insert->Keyframe* from the menu.

Click on the key frame 225 in the "text 2" layer and drag the text line graphic to the left until the wording aligns with the words in the "text 1" layer.

Click on the "text 2" layer and choose *Insert->Create Motion Tween* to animate the text. An arrow appears on the Timeline showing the animation.

Now, drag the key frame in "text 1" layer from frame 225 back to frame 1.

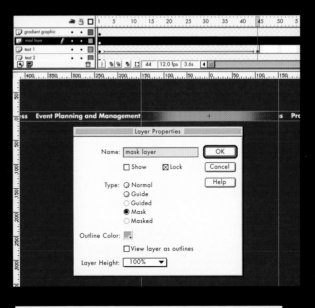

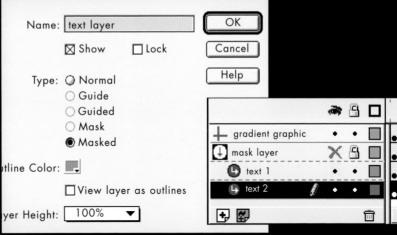

Next, scroll to the end of the Timeline to frame 225, and insert the cursor in frame 225 on the "text 1" layer. Click and drag to the left to highlight all empty frames up to the key frame in frame 1. Press the Delete key twice to delete all empty frames on this layer.

Click in frame 44 of the "text 1" layer and choose *Insert->Key Frame* from the menu. Click on the "text 1" layer name to highlight the entire layer. Choose *Insert->Create Motion Tween* from the menu. Drag the playhead in the Timeline to see scrolling text animation.

Next, double-click the icon at the far left in the "mask layer" layer. This brings up the Layer Properties dialog box. Select "Mask" and uncheck "Show." Select the "Lock" checkbox. Click OK. Notice how the icon changes to a circle with a red downward-facing arrow inside, showing it is a mask layer.

Double-click the icon at the far left in the "text 1" layer. Select Masked and click OK. Do the same for "text 2" layer. Purple circles with white arrows indicate they are Masked layers. Double-click the "gradient graphic" layer and select Guide for the property.

Mask Layers

The Mask layer allows objects placed on the Stage to show through only specifically defined areas of another graphic element. An example would be using a solid black circle as a Mask layer. Other objects placed on layers underneath this layer (masked layers) will only show through the black circle, even if they are larger than the circle.

8

With the Main scene Stage showing, open the Library, *Window->Library*.

Drag the "MCscrolling text" movie clip from the Library and place it on the Stage in the area where you would like the scrolling text to appear.

The final step is to test the movie by choosing *Control->Test Movie*. This will create a .swf file of the Flash (.fla) file and open the .swf for viewing using the Flash Player.

In the Aspen Marketing project, the designer created the scrolling text movie clip to fit within the white divider line separating the colorful button squares on the left of the screen, and the arcing swoosh that is part of the "S" in Aspen.

Placing the scrolling text in this area gives the text the illusion of fading in from the right side of the swoosh and fading out as it hits the right side of the white divider line.

Creating and Exporting a Transparent .png File from Adobe Photoshop

This element of the tutorial features an easy way to quickly export a .png file from Adobe Photoshop

1. Open a new file in Adobe Photoshop, name the file "transparent box," and give it these specs:
Width: 300 pixels
Height: 20 pixels
Resolution: 72 pixels/inch
Contents: Transparent
Mode: RGB Color
Once this is done, click OK.

2. Select the Gradient Tool in the toolbar. This shows the gradient editing options in the horizontal area at the top of the menu area.

3. Click the gradient editing area to bring up the Gradient Editor dialog box. Name the gradient "png fade."

The Adobe Photoshop gradient tools are similar to the Flash gradient tools. Notice the gradient arrows on the gradient bar. Click twice on the bottom and top of the gradient bar to create four new gradient arrows. Drag both top and bottom middle arrows toward the center of the gradient bar then drag the top and bottom end arrows away from the edges.

Color should be white for all middle arrows and black for all left and right outer arrows. Change the color of the arrows by double-clicking on the arrows to show the Color Picker dialog box. Choose the appropriate colors and click OK.

Select the two middle arrows one at a time and in the Opacity field, set opacity to 0 percent. This allows the gradient to be transparent in the middle.

The gradient should look like the one shown at right.

4. Add the gradient to the gradient Presets by clicking the New button. This places the new gradient in the pull-down gradient palette.

continued on next page

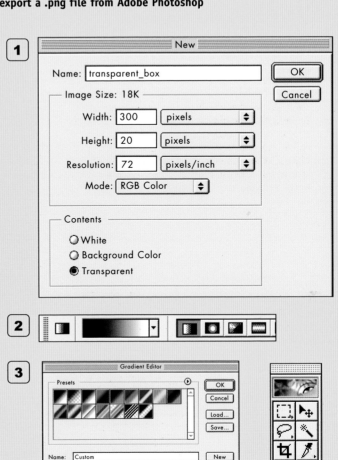

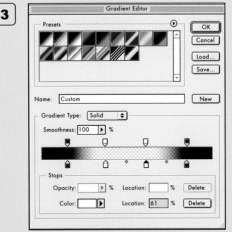

Creating and Exporting a Transparent .png File from Adobe Photoshop

Scrolling Text Fade .png tutorial

5. Select the Gradient Tool. Be sure the new gradient that was added to the gradient palette is also selected. Draw a line from the left edge of the Photoshop box to its right edge. Hold the *Shift* key down to constrain the gradient in a straight line. The gradient should look similar to the one at right.

6. Choose *Help->Export Transparent Image* from the Photoshop menu.

7. Use the Export Transparent Image Assistant to create the transparent .png that will be imported into Flash. Follow the prompts and select items in the following order:
a. My image is a transparent background
b. online
c. png
d. Save as file name "aspen_transp.png"
e. Finish

The final step will be to import the .png into Flash and replace the "gradient graphic" symbol.

8. Close Photoshop and reopen the Flash Scrolling Text Fade tutorial created earlier *(see page 24)*. Choose *File->Import* and select the .png file that was exported from Photoshop. Add the file and click the Import button.

9. The Fireworks PNG Import Settings dialog box will appear. Select Flatten Image and check the Include Images box, then click OK.

5

6

7

8

9

Incorporating .pngs into Flash

The .png (Portable Network Graphics) format is the only file type that supports an alpha channel to handle transparencies in Flash. Adobe Photoshop is an easy program in which to create a .png file for importing into Flash.

Keep in mind that .png files add considerably more file size to a Flash movie and should only be used when Flash drawing tools won't suffice.

A good example is the cloud image that Aspen Marketing Group project designer Ryan Nielson created to show the flexibility of a .png file for creating special effects in Flash. Creating a texture such as the one at right and then following the same processes used to create the .png gradient for this tutorial would offer designers techniques that may not be possible in the Flash application.

With this cloud .png graphic, Flash text can be animated to scroll as if it is fading in and out of a cloudy background.

 9

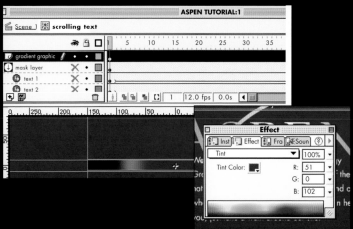

When imported into Flash, the Photoshop .png image appears in the center of the Flash Stage and also in the Library. *Cut* the graphic from the Stage.

Double-click the "scrolling text" movie clip in the Library. Double-click the "gradient graphic" in the editing window

and delete the "gradient graphic" while it is selected.

Paste the .png that was *Cut* earlier. If it is no longer in memory, drag the .png file from the Library.

Drag the .png file into the space between the guides where the

"gradient graphic" was deleted. Use the scene hierarchy to click and go back to the "scrolling text" movie clip. Notice that the black edges of the .png file are still showing where it was pasted into the "gradient graphic."

Select the .png object and choose *Window->Panels->Effect*. In the pull-down menu choose Tint and select the Tint Color #330066. The Tint effect blends the .png graphic into the background. Test the movie to confirm that it has the same effect that was achieved creating the "gradient graphic" in Flash.

< Animation: Simulating a Cursor Trail >

There are many advanced features in Flash that involve extensive ActionScript programming. These features can add to the dynamic interaction that users experience when they come to a Flash site, but many designers shy away from attempting to incorporate many of these due to lack of programming skills.

The simulated cursor trail used in the Cotaco portfolio site removes the need for advanced ActionScript programming and instead accomplishes all of the animation through tweening and button rollovers.

This tutorial showcases an easy and quick way to create a cursor trail. With this technique, a designer can have a dynamic effect in a matter of minutes.

To complete this tutorial the reader should know how to work with toolbox tools and modifiers, symbols and instances, the timeline and frame labels.

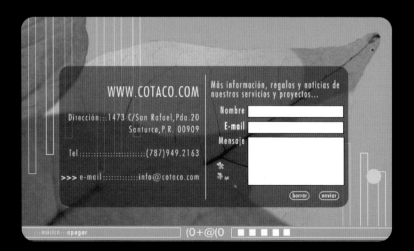

Cotaco Studio Portfolio

Project	Cotaco Studio Web Site
Design Firm	Cotaco Studio
Design	Carmen Olmo
Scripting	Carmen Olmo
Production	Carmen Olmo, Carmen Ortega
Software	Macromedia Dreamweaver, Adobe Photoshop, Cool Edit Pro
Country	Puerto Rico
URL	www.cotaco.com

Simulating a Cursor Trail

There is more than one way to create a cursor trail in both
Flash and other applications such as JavaScript. This project
incorporates button rollovers to simulate the cursor trails.

ASPEN TUTORIAL: 1

Scene 1 **scrolling text**

mask layer

text 1

text 2

The first step in this tutorial is
to create a new movie that will
contain the cursor trail. Rather
than create the full interface
of the Cotaco portfolio, this
project will be created in a
separate file.

Once this project has been com-
pleted, the design and technique
can be implemented in a number
of different ways, and is only lim-
ited by the designer's creativity.

Open a new file and choose
Modify->Movie to bring up the
Movie Properties dialog box.
Make the movie Dimensions 350
pixels wide by 350 pixels in
height. Set the Frame Rate to 20
to speed up the movie. Change
the Background Color to blue and
click OK.

Next, select the Rectangle Tool
from the toolbar and draw a
square on the Stage 16 pixels
wide by 16 pixels in height.
Choose *Window->Panels->Info*
and use the W and H Shape
\fields to make sure the box
is the exact size.

Convert to Symbol

Key commands are one of the most important parts of the
Flash program. Selecting an object on the Stage and hitting
the *F8* key will bring up the Symbol Properties dialog box
for the selected object. This dialog box allows the designer
to choose one of three Behavior options for the symbol.

2

Select the 16-pixel box that was
just drawn on the Stage and
choose *Insert->Convert to Symbol*
and select Button as the
Behavior. Name the button "invis-
ible button" and click OK.

Double-click the square to enter
the button edit mode. Click on
the key frame in the Up state and
drag it over into the Hit state.
Having the key frame only in the
Hit state will make the button
invisible on the Stage.

Return to the main Timeline in
Scene 1.

Select the button on the Stage
and choose *Insert->Convert to
Symbol*. This time, select Movie
Clip as the Behavior, name it "all"
and click OK.

Double-click the graphic once
again to enter the movie clip
editing mode. Rename "layer 1"
to "button" and create two new
layers. Name the layers from top
to bottom "actions," "animation,"
and "button."

Object Actions

There are two types of actions that can have scripts attached to them, objects and frames. In this example the object action is a rollover of a movie clip. When the user rolls over a movie clip, the playhead is sent to frame 2 of the current Timeline.

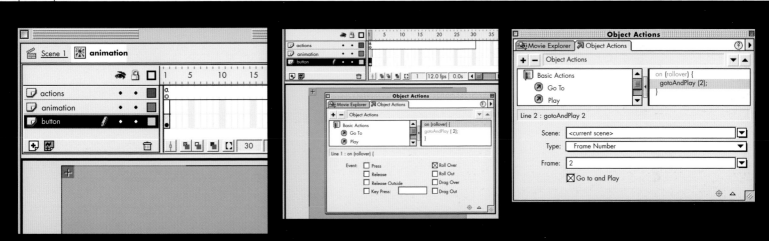

3

Double-click in frame 1 of the "actions" layer to bring up the Frame Actions window. Choose *(+)->Basic Actions->Stop*.

Select the button on the Stage.

If the Actions window is not open, choose *Window-> Actions*. In the Object Actions window, choose *(+)->Basic Actions->On Mouse Event*. Deselect the Release Event and select the Rollover check box.

Next, choose *(+)->Basic Actions ->Go To*. Type "2" into the Frame field. The script will look like this:

```
on (rollOver) {
  gotoAndPlay (2);
}
```

Scale and Rotate

The Scale and Rotate dialog box allows the designer to accomplish both actions at the same time, rather than performing one function and then going back and performing the second function. To rotate an object counterclockwise, type a minus sign before the percentage. A percentage without the minus sign will automatically rotate an object clockwise.

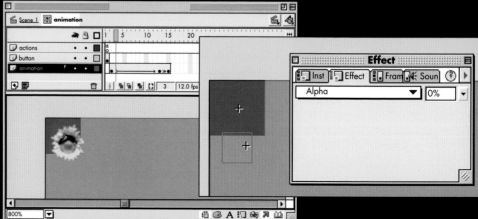

Next, select frame 2 of the "animation" layer and insert a key frame, *F6*. Draw an object—or import a JPEG graphic—60 pixels by 60 pixels in diameter. For this project, a transparent .png of a flower was used.

Select the imported graphic on the Stage and choose

Insert->Convert to Symbol. Select Movie Clip as the Behavior and name it "flower MC."

Select frame 15 in the "animation" layer and insert a key frame, *F6*. Click on the first key frame in frame 2 and choose *Insert->Create Motion Tween*.

Select frame 15 and choose *Modify->Transform->Scale and Rotate*. Scale the graphic 40 percent and rotate it 160 degrees. Nudge the movie clip down 20 pixels using the down arrow key.

With the "animation" layer still selected, position the playhead over frame 13 and insert a key

frame, *F6*. Select frame 15 once more and choose *Window->Panels ->Effects*. Choose Alpha from the pull-down menu and set it to 0 percent. Scrub the playhead. The animation now rotates, reduces in size, and fades away as each button is rolled over.

Creating the Rollover Animation

1. Return to the main Timeline of Scene 1 and select the first frame. Copy and Paste this symbol eleven times. Position the symbols across the top of the Stage as shown at right. Copy all eleven symbols and Paste again to create the full row across the top of the Stage. Once this is done, continue until the full Stage is covered with the symbols.

2. Test or Publish the movie. As the cursor passes over each small square on the Stage, it sets the rollover animation into action and gives the illusion of a cursor trail.

User Interaction

The *PC World* promotion project tutorial explores the videolike controls that allow the user to control the audio with rewind, fast-forward, stop and play buttons. To create the controls the designer mimicked the fast-forward and rewind by jumping forward and backward in the Timeline.

~

The Frontera Flash portfolio project offers clients access to projects through a password-protected area.This tutorial demonstrates an easy way to create a user log-in that gives clients access to specific areas of a design studio s portfolio.

~

The first *WWW Design* Web site tutorial describes how to implement a scrolling text box containing buttons used to navigate the Timeline. The second describes how to access a text file from the server that includes HTML tags.

~

The Popsicleriot tutorial features a contact form created in Flash and shows how to build the Flash form and the submit button, as well as describing how to use the PHP script and adjust it for use in a Flash Web site.

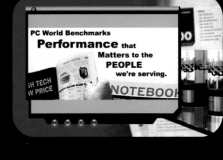

When creating a large or small Flash animation project, there are a number of important elements to take into consideration. Perhaps the most important of these elements is the user interaction that will take place throughout the project. Forgetting small details like back buttons, audio off buttons, or next and previous buttons can distract from the overall presentation and ruin a potentially great project.

The *PC World* promotion project was created by In Your Face New Media for *PC World* magazine's marketing department. The full site featured thirty-two pop-up windows and more than two hours of voice-over recordings explaining the various aspects of the magazine's print and online divisions.

This tutorial explores the videolike controls that allow the user to control the audio with rewind, fast-forward, stop, and play buttons. To create the controls the designer mimicked the fast-forward and rewind by jumping forward and backward in the Timeline.

To complete this tutorial the reader should know how to work with drawing tools, button symbols, tweening, and the library.

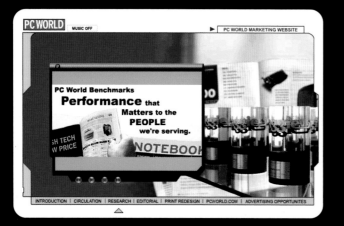

PC World Magazine Promotion

Project PC World Magazine Promotion
Design Firm In Your Face New Media Design
Design Daniel Donnelly, Jesse Hall
Scripting Jesse Hall, Shoko Horikawa
Production Jesse Hall, Shoko Horikawa
Software Adobe Photoshop
Project Manager . Amy Dalton (PC World Marketing)
Country U.S.A
URL www.pcworld.com

Simulating Audio Control Buttons

Giving the user control of the audio buttons will add to the usability of your project. Rather than making the Flash animation play straight through, this control allows the user to rewind, pause, and fast-forward through the audio and animation.

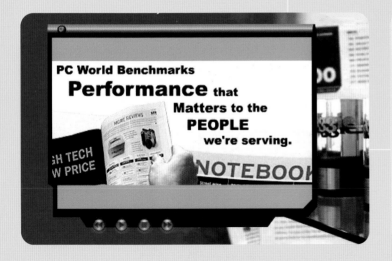

Before creating audio control buttons for this *PC World* project, the designer first created an interface pop-up window for the buttons (above right). This box is the Child .SWF file that is loaded into the Parent .SWF movie in the main interface (above, and inset facing page).

A gray movie background helps the designer easily see the white outline of the pop-up window's Stage where animation will take place. A stroke around the white background frames the pop-up window interface.

The empty gray area at the bottom of the window, just beneath the white background, is where the final audio control buttons will be placed.

The gray area of the background will be transparent when it is placed on the main file for playing the animation, and all four buttons will sit directly on top of the dark gray bar created as part of the final interface.

The First Step

Create the four audio buttons that will be used to control rewind, stop, play, and fast-forward. These buttons control the animated Flash movies that were created for each section of the *PC World* project.

2

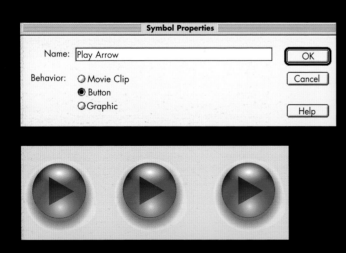

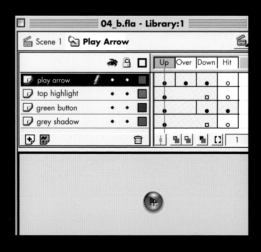

First, create a button symbol by choosing *Insert->New Symbol* from the menu. In the dialog box, enter the name "Play Arrow" for the button and select Button for the Behavior.

Button states give the user feedback as the cursor rolls over the button.

Draw a circular button that can be used for the play control. Draw a right-facing arrow on the button to show the user the button's function. Next, click in each button state to add a key frame and create a different effect for each state.

The Up state is a green circle with a dark green arrow; the Over state is a green circle with a white arrow; the Down state is a black circle with a white arrow. Hit state is a green circle.

Duplicate the original play button two more times using the Options menu located at the top right of the Library palette *Options->Duplicate*.

Using the Flash Library

The button design used for this project is a gel button, which can be found in the Flash Button Library. Go to *Window->Common Libraries->Buttons*.

(If you use buttons from the Flash Library, skip to step 6.)

3

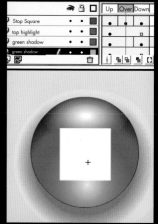

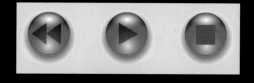

After duplicating the play button twice, rename the buttons by double-clicking the button name in the Library palette. (Double-click the name text, not the icon.) Give each button the name of the function it will be used for: rewind, play, and stop.

Next, in order to create additional buttons, you will need to remove the arrow graphic and replace it with stop squares as shown above. Be sure to replace graphics on the Up, Over, and Down states.

You can create the first square graphic on the Up state, and then use the *Menu->Copy*, and *Menu->Paste in Place* commands to paste the graphics in the exact place they are located on the previous state.

Next, create the rewind control button with the double arrows. Don't create a new button for the fast-forward control; instead, reuse the rewind control symbol and flip it on the Stage for the fast-forward control button.

Naming Conventions

Naming conventions help keep the content of a Flash site organized. Consistent naming of layers and files allows another designer working on the project to locate layers or find objects in the Library quickly.

Name layers as soon as they're created. This will help to keep track of elements throughout the design process, rather than having to name them later.

4

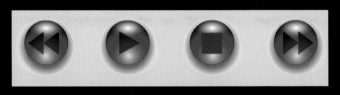

Create a new layer and name it "buttons." Double-click on the new layer text to highlight it.

Next, click the first frame in the "buttons" layer and drag all of the buttons to the Stage.

Align buttons, click on the rewind button on the Stage and *Copy*, then *Paste in Place*. This will paste a copy of the rewind button directly on top of the original button.

Drag the button copy to the right of the stop control button. Holding the *Option/Shift* or *Alt/Shift* keys down as you drag will constrain the graphic horizontally on the Stage.

With the copied button still selected go to the menu and choose *Modify->Trans-form->Flip Horizontal* to change the control direction. The copied rewind button is now facing the other direction and is a fast-forward button.

Importing Audio into Flash

1. Create a new Flash document. Resize the Flash window to see both the audio files on the hard drive and the Flash Stage. There are two ways to import audio files, either drag and drop the .wav, .aif, or .mp3 files on to the Flash Stage or use the import function: *File->Import...*, and choose All Sound Formats or the specific sound format from the pull-down menu.

2. Create a new layer: *Insert->Layer* or use an existing layer. Name the layer "Audio." Note: It's usually best to place audio files on their own layers to avoid confusion and make elements easier to find and update.

3. Choose where on the Timeline the audio file should begin and insert a key frame: *Insert->key frame* from the menu.

4. Double-click the key frame in the Audio layer to bring up the Frame panel and choose the Sound Tab, or use the menu: *Window ->Panels->Sound* to pull up the panel directly to the Sound Tab.

5. For now, leave the audio event as *Sync->Play* with the other Loop and Effect menus to see how they change the audio.

6. Click further out in the Timeline on the Audio layer and insert a new frame: *Insert->Frame* to stretch the audio out to its full length.

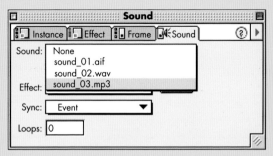

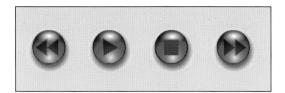

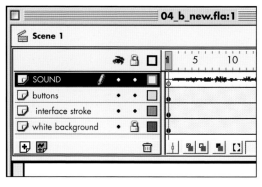

With all buttons placed on the Stage, create a new layer for the sound file and name the layer "Sound."

Import a sound file and drag it from the Library on to the Stage or directly into the Sound layer.

At this point, the Control buttons have functionality for rollovers, but no scripting to tell them what to do.

Test the functionality by choosing *Control->Enable Simple Buttons* from the main menu. Roll your cursor over the buttons to view the Over state and click on them to view the Down state.

Be aware that buttons cannot be selected to add scripting while *Enable Simple Buttons* is still on.

The Movie Explorer

Use the Movie Explorer to quickly find scripting information for specific frames or elements in Flash, such as audio clips, buttons, movie clips, or graphics.

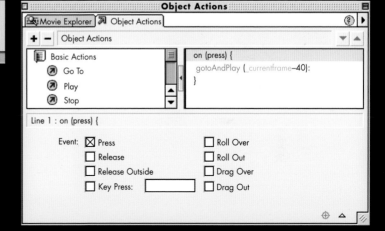

6

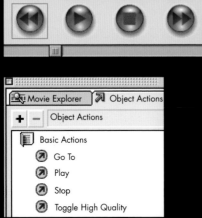

To script the buttons, open the Actions window, *Window->Actions*.

Next, click on the rewind control button on the Stage to select it.

Click on the (+) icon at the top of the Object Actions window and through the hierarchical menu choose *Basic Actions->Go To*.

Uncheck the Release Event box and check the Press Event box. The code should now read

```
on (press)  {
 gotoAndPlay (1);
```

Change the script to read:

```
on (press) {
 gotoAndPlay (_current
frame-40);
}
```

This script tells the playhead to look at the current frame in the Timeline and jump backwards forty frames each time the rewind control button is clicked by the user.

The rewind control button will use similar scripting.

Event Scripts

Choosing the *Go to* and *Play* actions offers eight different Event Actions to choose from:
1. Pressing the mouse button
2. Pressing and releasing the mouse button
3. Releasing the mouse button outside of an object
4. Pressing a key on the keyboard
5. A cursor rollover
6. An action as the cursor rolls off (or outside of) an object
7. An action looking to see if the user is dragging an object over another object
8. An action to see if the user is dragging an object outside of another object

The most widely used of these are the Press and Release Event Actions.

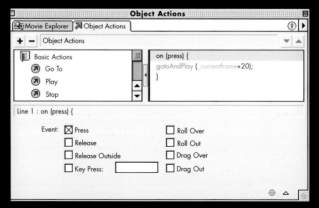

7

Click the fast-forward button on the Stage to select it.

Click on the (+) icon at the top left of the Object Actions window and through the hierarchical menu choose *Basic Actions->Go To*.

Uncheck the Release Event box and check Press Event. The code should now read
```
on (press) {
  gotoAndPlay (1);
}
```

Change the code to read:
```
on (press) {
  gotoAndPlay (_current-
frame+20);
}
```

This code tells the playhead to look at the current frame in the Timeline and jump ahead twenty frames each time the fast-forward control button is clicked by the user.

Basic Object Actions

The basic object and frame actions such as Stop, Go To, Play, and Get URL can be accessed through a hierarchical menu using the (+) icon located at the top left of the Object Actions window.

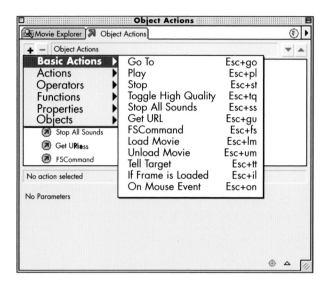

8

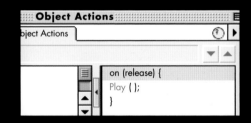

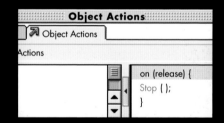

Add the scripting to the stop and play control buttons.

Click the play control button on the Stage to select it.

Click on the (+) icon at the top of the Object Actions window and through the hierarchical menu choose *Basic Actions->Play*.

The code will now read:
```
on (release) {
 play ();
}
```

Click the stop control button on the Stage to select it.
Click on the (+) icon at the top of the Actions window and through the hierarchical menu choose *Basic Actions->Stop*.

The code will now read:
```
on (release) {
 stop ();
}
```

< User Interaction: Creating a Password Log-in >

Learning to work and communicate clearly with clients is one of the most important elements of running a successful design studio. Setting up a Web site where clients can access comps and view the progress of their projects can be a valuable tool in creating clear avenues of communication.

Frontera Design's owner and designer, Patrick Lang, produced this portfolio to offer potential clients a look at the studio's past and current work. It also lets clients access projects through a password-protected area.

Flash often offers several ways to accomplish one specific objective, either through scripting or design, a sometimes frustrating, sometimes valuable facet of the application. With that being the case, there is more than one way to create a password log-in. This tutorial demonstrates an easy way to create a user log-in that gives clients access to specific areas of a design studio's portfolio.

To complete this tutorial the reader should know how to work with drawing tools, buttonsymbols, tweening, the library, and Basic ActionScripts.

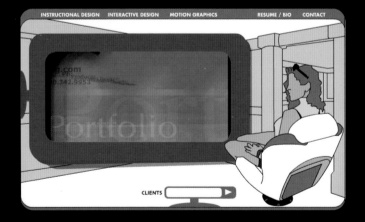

Frontera Design Portfolio

Project Frontera Design Portfolio
Design Firm Frontera Design
All Design Patrick Lang
Software Adobe Photoshop, Adobe Illustrator
Country U.S.A
URL www.plang.com

Creating a Password Log-in

Creating a password input area by using the code shown in this tutorial gives designers a quick and easy way to offer a secure area of their Web sites to clients. This area can also be used to make a simple entry to secure in-house areas.

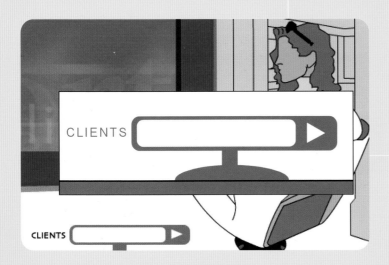

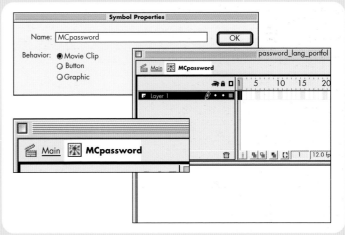

The first step in creating the password input field is to design the graphic that will contain the input text. Frontera Design's portfolio features a client input module that slides into view from the bottom of the screen.

The size and design of the module is unobtrusive and fits well within the project's interface.

Before beginning to draw the input field graphic, create a new movie clip where the entire graphic will reside. Placing all of the graphic elements in one movie clip will help when editing the graphic or reusing the movie clip in other projects.

Choose *Insert->New Symbol* to bring up the Symbol Properties dialog box. Be sure to select the movie clip Behavior. Name the movie clip "MCpassword" so that it will be easily recognizable in the Library.

The movie clip will open in an editing window. If this isn't the case, double-click the movie clip icon in the Library to get to the symbol's editing mode.

The editing path is shown at the top of the Flash window, Interactive: MCpassword. The path shows the main Scene and the movie clip "MCpassword" icon.

Organizing the Flash Library

Organization is the backbone of designing any large project. Small projects, however, also need to be organized to keep processes streamlined. Use folders whenever possible. Creating folders in the Flash Library is the easiest way to organize specific elements that belong together. This technique makes it much easier for other designers who may later have to update the project to find the appropriate elements.

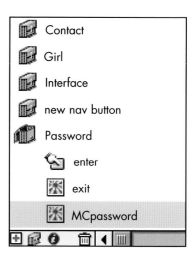

2

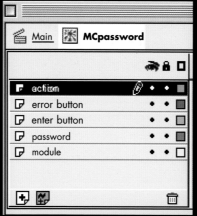

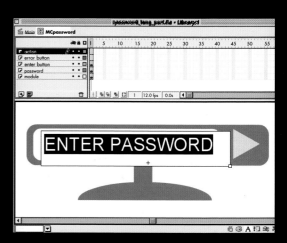

While still in the editing area for the "MCpassword" movie clip, draw a graphic that will contain the password text field.

Double-click the "Layer 1" text to highlight the text and rename the layer "module" as shown above.

Next, create four new layers. This can be done by using the Flash menu *Insert->Layer*. Or, a faster way is to click the Insert Layer (+) icon at the bottom of the layer area. Try both ways and see which is quicker.

Next, name the layers as shown above. Starting with the bottom layer "module," and moving up: "password," "enter button," "error button," and "action" as the top layer name.

Choose the Text Tool from the tool-bar and draw a text box to fit the password field of your graphic. This will be the input field for the user to type in a password.

Character Panel

To adjust the text in your project, choose the Character panel. This panel offers designers the option of choosing various fonts loaded on the host computer's system, adjusting the size and tracking, auto kerning, color, and other basic text attributes.

An additional option (not used in this tutorial), is the URL entry field, which offers the option of adding a direct Web link to any text.

3

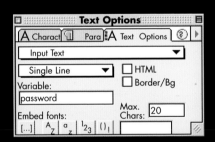

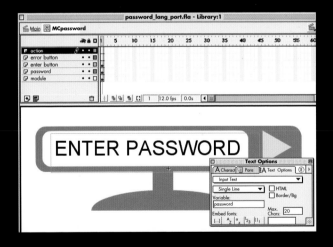

Format the text using the Character panel. Be aware, the text attributes you give this text field—color, size—will be what users see when typing passwords in the final project.

(Do not click off the text box. The box will disappear if no text is typed in it before the next step.)

With the text box still selected, click the Text Options tab on the Character panel, then choose Input Text from the top pull-down menu. Choose Single Line from the second pull-down menu.

Uncheck the Border/Bg checkbox. This will make the text field transparent on the graphic.

Leave the Max Chars box blank unless you know that you would like to limit the user to typing in only a specific number of letters.

Type "password" in lowercase letters in the Variable input field.

The Variable "password" will be referenced in the final code. (See page 59 for the full code.)

The final code looks for the "password" Variable that is attached to the input text field, and then processes the correct function based on what it is scripted to do.

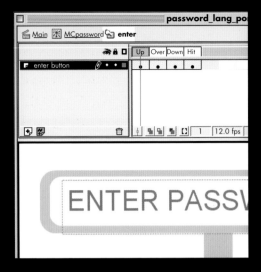

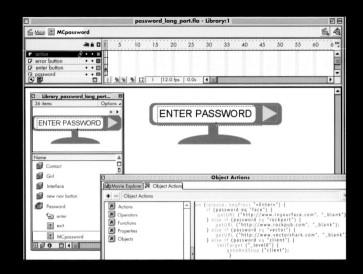

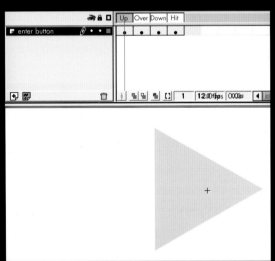

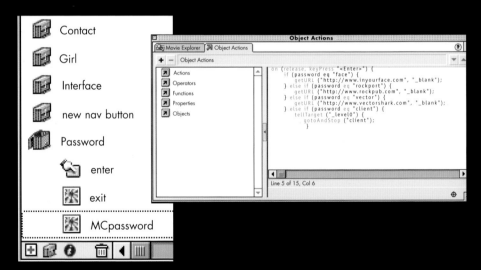

Create an enter button to access the final ActionScript.

This portfolio incorporates a basic gray arrow for the enter button, which is placed next to the password input field.

To create the button, choose *Insert->New Symbol* from the menu bar. In the dialog box, be sure to choose Button and name the button "enter" before clicking OK.

The Button Edit window will appear, showing a key frame in the first Up button state. Choose a fill color from the toolbar to color the arrow, then press the *F6* key three times to fill all button states. Choose a different color for each state.

Click Main Scene at the top of the window to return to stage.

Next, open the Library panel and double-click the icon for the "MCpassword" movie clip. Select the "enter button" layer and drag the enter arrow button on to the password graphic. Click the arrow graphic on stage and choose *Window-> Actions* from the menu.

The next step will be to type or paste the main ActionScript code into the Actions window.

5

ActionScript for Enter Button

This script and corresponding .fla can be downloaded from the Rockport Web site: www.rockpub.com/wtt_flash/resources

Deciphering ActionScript code can be complicated and frustrating. The ActionScript at right is shown exactly as it needs to be typed in the Object Actions window when it is attached to the "enter" button. To make understanding the code easier, a line-by-line breakdown of what each piece of code does is offered below.

To paste the ActionScript code, make sure the Object Actions window is open, choose Expert Mode from the options arrow at the top of the window, or use the *Command-E* key command to switch to Expert Mode. Use *Command-N* to switch back to Normal Mode.

```
on (release, keyPress "<Enter>") {
    if (password eq "face") {
        getURL ("http://www.inyourface.com", "_blank");
    } else if (password eq "rockport") {
        getURL ("http://www.rockpub.com", "_blank");
    } else if (password eq "vector") {
        getURL ("http://www.vectorshark.com", "_blank");
    } else if (password eq "client") {
        tellTarget ("_level0") {
            gotoAndStop ("client");
        }
    } else {
        gotoAndStop ("error");
    }
}
```

Object Actions — Line 5 of 15, Col 6

Line 1: If the user hits the Enter key, it will do the same as if they clicked the Enter button.

Line 2: If the user types in "face" as the password, the www.in-your-face.com URL will open in a new browser window (_blank).

Lines 3–7: These lines follow the same code example as line 2.

Lines 8–10: If the password equals "client" (the correct password), Flash sends the playback head to the main scene ("_level0"), and then tells the playback head to go to the label "client" and then stop. (See step 7 for definition of labels.)

Line 11: Close bracket shows the start of a new line of code.

Lines 12–13: This code looks at the input area to see if the user has entered the correct password in the text input field. If the user has entered an incorrect password, the script sends the playback head to the "error" label also located in the main scene ("_level0").

```
1-   on (release, keyPress "<Enter>") {
2-       if (password eq "face") {
3-           getURL ("http://www.inyourface.com", "_blank");
4-       } else if (password eq "rockport") {
5-           getURL ("http://www.rockpub.com", "_blank");
6-       } else if (password eq "vector") {
7-           getURL ("http://www.vectorshark.com", "_blank");
8-       } else if (password eq "client") {
9-           tellTarget ("_level0") {
10-              gotoAndStop ("client");
11-          }
12-      } else {
13-          gotoAndStop ("error");
14-      }
15-  }
```

Organizing Layers: Name Them!

The most important element of the Layers window is the ability to name each layer. Often designers who work alone—or those who work as the primary creative on a project—forget the importance of naming layers in Flash. There are few things more frustrating than receiving a file from another designer where all of the layers in a project are named "Layer 1," "Layer 2," "Layer 3," and so on.

Without naming, the next designer who opens the file will have to "hunt and peek," turning layers on and off to figure out where a particular button or graphic is located.

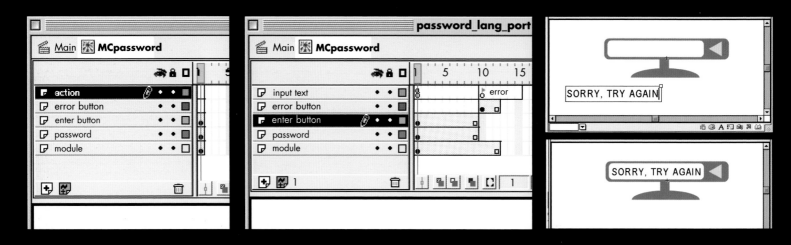

6

Now that the ActionScript code has been attached to the enter arrow, the next step is to fill out the frames in the Timeline.

The current Timeline should look similar to the graphic above, with key frames for the "module" layer, "password" layer, and "enter button" layer.

The "error" layer and "action" layer should have blank key frames because nothing has been added to those layers yet.

Select frame 12 of the module layer by clicking in the frame. Choose *Insert->Frame* from the menu (or use the *F5* key).

The *F5* command duplicates the first frame and fills all frames up to frame 12. Select frame 9 in the "password" layer and press *F5* to fill all frames. Do the same on the "enter button" layer.

The next step is to create and place the "error button" text. Click in frame 1 of the "error button" layer. Using the Text Tool, create a new text box and type an "incorrect password" phrase. For this project, the phrase is "SORRY, TRY AGAIN."

Labeling Frames in the Timeline

Labels in the Timeline can be used for two different purposes. The first is to label a frame that will be referenced in a specific script within the Flash project (such as the way the "error" label is referenced in the "action" layer from the "enter button" script). Use this type of label to send a playhead to a specified frame in a scene's Timeline.

The second purpose is to write comments into a frame so other designers will know what was done in a certain area of a Timeline. When writing comments, be sure to type two forward slash marks (//) at the beginning of the label text.

7

Drag the key frame in frame 1 of the "error button" layer to frame 10. Select frame 12 and fill frames using the *F5* key.

The final step in creating the "MCpassword" movie clip is to add a Stop Action in the first frame of the "action" layer, and a label in frame 10.

Double-click the first frame in the "action" layer. This brings up the Frame Actions window. Double-click the Stop action.

No action can be seen while the frame is highlighted. Clicking in another frame or on the Stage will allow the action icon (a) to be seen.

Select frame 10 in the "action" layer. With this frame selected, insert a new key frame using the *F6* key. Double-click in frame 10 to bring up the Frame Actions window. Double-click the Stop action.

Next, select the Stop Action in frame 10 and choose *Window->Panels->Frame* from the menu. In the Label box, type "error." This label tells the playhead to go to this frame when an incorrect password is typed into the password input field.

More about Layers

When a new layer is created, Flash places it just above the previously selected layer. Projects with many layers force the designer to scroll up and down to view layers. Be sure to consider where a layer should go in the hierarchy before inserting a new one. Hidden layers in the scroll bar are less likely to get named right away.

Layers can always be dragged from one place on the hierarchy to another, but a little bit of planning can save a lot of time in the long run.

8

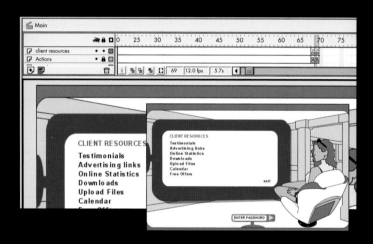

The final step in creating this project tutorial is to add a client resource screen that can be accessed only through typing a password.

Return to the main scene by clicking on the main scene icon at the top of the Flash window.

Create a new layer by clicking the (+) icon on the layer window. Name the layer "client resources."

Select a frame on the "client resources" layer Timeline and insert a key frame. Select the next frame over and insert another key frame. Use the *F6* key for inserting each new key frame.

The first part of this project Timeline is used for an intro animation, so the designer placed the "client resources" further into the Timeline.

Select the first key frame that was inserted, choose *Window->Panels ->Frame* from the menu. In the Frame panel, type "begin" in the Label field. Select the next key frame and type "client" in the Label field. The key frames should each show a small label flag icon.

Copying and Pasting Code

To copy ActionScript code from the Actions window, choose the Expert Mode from the window's option arrow pull-down menu, located at the top right of the window. Use Command-N (Mac), or Control-N (Windows) to toggle from one mode to another using the keyboard shortcuts

9

```
on (release, keyPress "<Enter>") {
    if (password eq "face") {
        getURL ("http://www.inyourface.
    } else if (password eq "rockport") {
        getURL ("http://www.rockpub.co
    } else if (password eq "vector") {
        getURL ("http://www.vectorshark
    } else if (password eq "client") {
        tellTarget ("_level0") {
            gotoAndStop ("client");
        }
    } else {
        gotoAndStop ("error");
    }
}
```

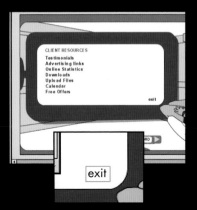

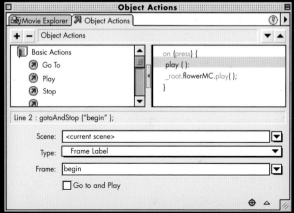

Notice that the "client" label that was placed in one of the newly created key frames is referenced by code toward the bottom of the script:

```
else if (password eq
"client") {
    tellTarget ("_level0")
{
```

```
    gotoAndStop
("client");
```

This script sends the playhead to the "client" label on the targeted main scene if the password equals "client" and then stops on that label.

The "begin" label is referenced in an exit button on the client resources layer. Using the Text Tool, type the word "exit" as shown above. Choose the Arrow Tool while the "exit" text block is selected. Press the *F8* key and select Button as the symbol. Name the button "exit" and click OK.

Choose *Window->Actions* and using the (+) icon, choose *Basic Actions->Go To*. Uncheck the Go to and Play checkbox. Select Frame Label from the pull-down menu and type "begin" in the Frame field.

Choose *Control->Test Movie*.

< User Interaction: Scrolling Text Boxes >

Working with large amounts of text or long lists in Flash can often be the most difficult element of a project to work through. Many designers—especially nonprogrammers—opt to open a browser and create a new HTML file that contains the scrolling text, rather than learn to create a scrolling text box. But Flash offers several ways to create scrolling text boxes, two of which are described in this tutorial. Once learned, the processes can be invaluable to creating and implementing successful designs.

This Flash project was created by In Your Face New Media as a companion to the *WWW Design Flash: The Best Web Sites from around the World* book. The site features designers and studios from the book—as well as resource lists—in scrolling text boxes.

This tutorial describes how to implement a scrolling text box containing buttons used to navigate the Timeline, and also describes how to access a text file from the server that includes HTML tags.

To complete this tutorial, the reader should know how to work with: drawing tools, button symbols, tweening, and the library.

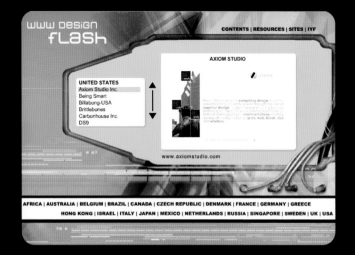

WWW Design: Flash from around the World

Project	WWW Design Promotional Web Site
Client	Rockport Publishers
Design Firm	In Your Face New Media Design
Design	Daniel Donnelly
Scripting	Jesse Hall
Production	Daniel Donnelly, Jesse Hall
Software	Adobe Photoshop
Country	U.S.A
URL	www.inyourface.com/flashworld

1 | Creating a Scrolling Text Box

The designers of the *Flash from around the World* site wanted an easy way to create a scrolling text field with links to the online resources and Web sites featured in the print version of the book. This tutorial shows how to create a Flash movie file that can access an HTML file for easy updating and also features a scrolling list with buttons attached for linking to URLs.

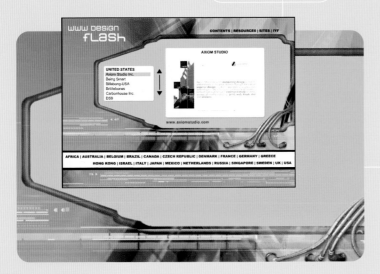

Because the designer wanted a look for this project that couldn't be easily created using the Flash drawing tools, a single large JPEG graphic was used as a background image, with all other elements created in the Flash program.

The first step in the design process was to create an interface in Adobe Photoshop incorporating the Flash elements, such as a scrolling text box, a project inset image, project title, Web link, and three additional navigation buttons.

With Flash open, create a new movie and open the Movie Properties, *Modify->Movie*. Set the Frame Rate to 30 fps (frames per second). This high frame rate will ensure all elements move smoothly throughout the movie. A slower frame rate could allow the movie to lag in some areas.

Set the movie size to 700 by 500 pixels. Click OK.

Import the background JPEG. The JPEG will be positioned on the Stage and in the first frame of Layer 1. Rename Layer 1 to "background."

Using the Info Panel

The Info panel can be used to scale an image to exact width and height parameters. It also allows the user to set the vertical and horizontal registration of an object on the Stage by typing in the x and y coordinates.

2

Next, create four new layers above the "background" layer using the (+) icon located at the bottom of the Timeline. Name the layers from the bottom up: "text," "boxes," "buttons," and "actions." Blank key frames are inserted in the first frame of each new layer created.

Select the background graphic on the Stage and choose *Window ->Panels->Info*. In the Info panel, change the x and y coordinates fields to 0. Be sure to select the upper-left corner of the registration point. This allows exact positioning of all objects to this point.

Next, select the first frame of the "boxes" layer and draw two white boxes. Double-click the Rectangle Tool to obtain the Corner Radius settings to create rounded corners. A radius of 6 was used on the boxes above.

Use the Info panel once again to set the smaller left box to a size of 152 by 103 pixels and a position of 126 by and 139 y. Set the larger box to a size of 300 by 204 pixels and a position of 311 x and 87 y. Be sure to check that the registration point is set to the upper-left corner.

3

Select frame 1 of the "text" layer. This layer contains the country names that will have rollovers buttons on top of them. Choose *Window->Panels->Character* to adjust the type characteristics. The first button that will be drawn is the "USA" button. Code will also be placed on this button.

Select the "buttons" layer and draw a black rectangular box (with a black stroke) on the Stage 30 pixels wide by 16 pixels in height. Use the Info panel for the exact size. With the box selected, press the *F8* key to *Convert to Symbol*. Name the button "main rollovers," select Button, and click OK.

Open the Library and double-click on the "main rollovers" button icon to open it in the button edit window. A default key frame appears in the first Up state of the button states. Press the *F6* key three times to fill all states (Over, Down, Hit) with key frames. This copies the key frame into all frames.

Select the first Up state key frame and delete. Next, select the Over state and delete just the fill and side strokes from the button. There should be two strokes left on top and bottom. In the Down state, delete fill and strokes again and change remaining stroke lines to an orange stroke color.

Invisible Buttons

The Hit state is used to create invisible buttons such as the one at right. Rather than include an Up state, the designer chose to incorporate a simple text link with no visible button on top of it. When the user rolls the cursor over the button's Hit state, an Over state shows two thin black bars and the Down state changes the color of the bars.

4

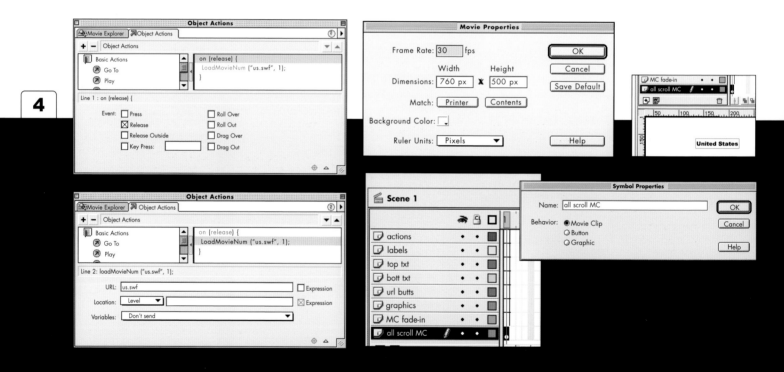

Return to the main Timeline (Scene 1) and select the button that was just created. The button has a blue tint because the Hit state was the only state left with a solid fill object. Choose *Window -> Actions*. Select *Basic Actions* from the (+) icon and choose *OnMouseEvent*. Leave the default

to *Release*. Next, select *Basic Actions->Load Movie*. Type in "us.swf" in the URL field and type "1" in the Location: Level field. When the user clicks on the "USA" button the "us.swf" movie–that will be created next–will load into level 1 on top of the current movie.

This next part will be showing how to create the "us.swf" movie that will be loaded into the main movie.

Create a new movie the same size as the main movie file. Create eight new layers and name them, from the bottom up: "all scroll

MC," "MC fade-in," "graphics," "url butts," "bott txt," "top txt," "labels," and "actions." Select frame 1 in "all scrolling MC" and type "United States" on the Stage in 11 pt, Arial Black. Choose *Insert->Convert to Symbol*, select Movie Clip and name it "all scroll MC."

5

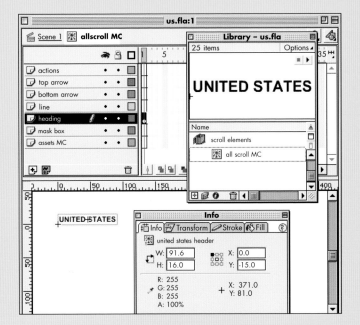

Open the Library and double-click the "all scroll MC" movie clip icon to open the symbol's editing window. Select the Layer 1 and name it "heading." Create six new layers, two below "heading" and four above "heading." Name the layers from the bottom up: "assets MC," "mask box," "heading," "line," "bottom arrow," "top arrow," and

"actions." Next, select the "heading" layer and choose *Window->Panels->Info*. In the Info panel change the x position to "0.0" and the y position to "-15.0," as shown above.

It's now time to create the "assets MC" movie clip. Select frame 1 of the "assets MC" layer and type

out a list ten text links. The ones shown above are design featured Web sites. Set the type to 11 pt, Arial Black.

Once the text is typed in a list, choose the Arrow Tool and select the text block. Choose *Insert->Convert to Symbol*, name the symbol "assets MC," and

select movie clip. Click OK. Double-click the "assets" movie clip icon in the Library to edit. Rename "Layer 1" to "text list." Create two more layers below "text list" and name them from bottom to top, "invis buttons," and "place holder."

While still in the "assets" movie clip, click on the text list once to highlight it and, using the Info panel, change the x position to "0.0" and the y position to "-2.0" as shown above.

Next, select the "place holder" layer and draw an orange rectangle 150 pixels wide by 12 pixels high. With the box selected, press the *F8* key to *Convert to Symbol* and name the movie clip "rectangle." Position this graphic at "0.0" x and "0.0" y.

With the orange "rectangle" still selected, choose *Window->Panels ->Instance*. In the Instance panel, type in "placeHolder" in the Name field. (Note: Be sure that there are no spaces after the name or the instance will not work.)

Select the "invis buttons" layer and drag an instance of the "rectangle" button onto the Stage. While the rectangle is still selected, press *F8* to *Convert to Symbol* and select Button and name it "invis button." Double-click the "invis button" in the Library to get to the button-editing mode.

The Instance Panel

The Instance panel is used when the designer needs to reference a specific element through scripting. The "placeHolder" name used for the movie clip allows the designer to reference the movie clip. Selecting a movie clip and pressing the *Command-I* keys will bring up the Instance panel. Always be sure to write out the instance Name with no spaces before or after the letters or the instance will not work properly when referenced through the scripting.

7

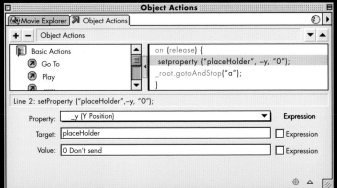

In button edit mode, press the *F6* key three times to fill all Button states. Delete the key frame in the Up state. Click in the Over state and choose *Window->Panels->Effect*.

Choose Alpha in the pull-down menu and change the transparency to 69 percent. Exit the button edit mode and return to assets. Select the "invis button" on Stage. In the Info panel, change the x and y positions to 0.0.

Choose *Window->Actions* from the menu. Using the basic Actions (+) icon pull-down menu, select *On Mouse Event* and use default selections.

Next, select (+)->*Actions->Set Property*. Type in "placeHolder" for Target. Leave the Value field empty for now. In the Property pull-down menu select _y (Y Position).

Select (+) *Actions->Evaluate* and in the Text field type in
`_root.gotoAndStop("a")`.

This final script for the sets the position of the placeholder movie clip to the line last selected by the user, and sends the playhead to a Frame Label on the main Timeline "a." Next, duplicate the button, give each individual parameters.

Adding Object Actions to Buttons

Each of the invisible buttons at right has a script attached it. The light blue color shows that it is a button with only the Hit state showing. To attach a script to a button, first click on the button image to select it on the Stage and then open the Actions window. If the button is not selected on the Stage, an object action cannot be added to it.

8

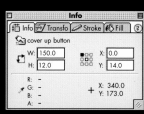

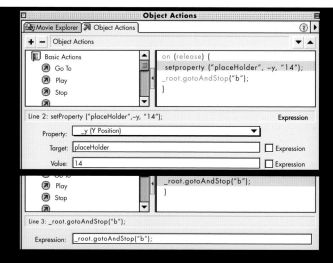

Continue working in the "assets" movie clip. Lock the "text list" layer so the layer content can't be moved. Turn off the "placeholder" layer. Select the first invisible button on the Stage using *Copy->Paste*, and drag the new invisible button below the first. Do this for all items in the menu list as

shown above left. When an invisible button covers each list name, begin changing the y position on all of the buttons in this list.
In order from top to bottom, they should be: 0, 14, 28, 42, 56, 70, 84, 98, 112, 126.

The next step is to adjust the scripts for each button. Open the *Window->Actions* panel and select the "placeHolder" line. Change the Value to the same sequence as the previous numbers: 0, 14, 28, 42, 56, 70, 84, 98, 112, 126.

Select each button separately and choose the "_root..." line of scripting to change the Expression for all buttons. In sequence from top to bottom, they should read: a, b, c, d, e, f, g, h, i, j. This finishes up the "assets" movie clip. Open the "all scroll MC" movie clip Timeline.

Layer Properties

Double-clicking on a layer icon in the layers area of the Timeline will open the Layer Properties dialog box. These properties allow the designer to lock a graphic or make it a guide layer, a mask layer, or a masked layer.

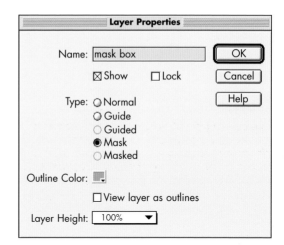

9

Select the "all scroll MC" movie clip on the Stage and open *Window->Panels->Instance* and type "assets" into the Name field.

Select the first frame in the "mask box" layer. Draw a box without a stroke that is 145 pixels wide by 85 pixels height. Place it at 0 x and 0 y using the Info panel.

Select the "mask box" layer and double-click the layer icon at the far left of the layer name. In the Layer Properties, select the Mask radio button, click OK.

Double-click the layer icon on the "assets MC" layer and check the Masked radio button.

Lock both the mask and masked layers to view the results of this operation. Only the first six lines of text show through where the hidden mask box has been placed.

Effect Panel: Tint

A tint can often be used in place of an Alpha transparency on a symbol. The Tint effect offers a choice of manipulating the RGB colors as well as the transparency of the tint when added to an existing graphic or color.

Choosing Tint can also speed up the processing of a movie when made into a .swf player file.

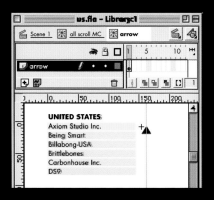

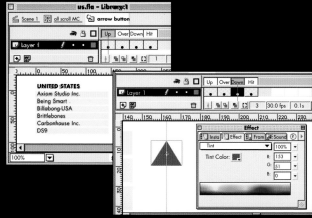

Select frame 10 in the "heading," "mask box," and "assets" layers and press *F5* to fill all frames. Select frame 10 in the "actions" layer and press *F6* to insert a new key frame. Double-click this key frame and choose "Stop" from the Basic Stop Actions window.

Next, create the up and down arrows for scrolling the menu.

Select frame 1 in the "top" arrow layer and draw an arrow head approximately 20 pixels high. With the arrow image selected on the Stage, press *F8* and choose Movie Clip in the Symbol Properties. Name it "arrow."

With the arrow selected on the Stage, press *F8* once again and choose Button as the Symbol and name it "arrow button."

Select the first frame in the "Up" state and press *F6* three times to fill all button states.

Select the key frame in the Over state and choose *Window-> Panels->Effect* and select Tint from the pull-down menu. Change the Over state to white and the Down state to red. With this done, return to the "all scroll MC" Timeline.

Scripting the Scroll Arrow Buttons

This scripting allows the user to scroll through the text links by clicking on the black up and down arrows.

1. Select the arrow button on the "all scroll MC" Stage and open *Window->Actions*. From the (+) pull-down menu select *Basic Actions->On Mouse Event*. Select the Press checkbox.

2. Select (+)->*Actions->Set Variable*. Type "pressing" in the Variable field. Type "true" in the Value field and select the Expression checkbox. (This scripting sets a variable that is detected by the parent movie clip and tells the clip if the user is clicking (pressing) the button.)

3. Select *(+)->On Mouse Event*. Select the "Release" and "Release Outside" checkboxes.

4. Select (+)->*Actions->Set Variable*. Type "pressing" in the Variable field. Type "false" in the Value field and select the Expression checkbox.

5. With the arrow button still selected, press F8 and choose Movie Clip as the symbol. Name it "arrow MC." Copy this movie clip and Paste it into frame 1 of the "bottom" layer. Position it on the Stage so it is below the other arrow head and choose *Modify->Transform ->Flip Vertical*, so that it points down.

6. Select the "arrow MC" movie clip in frame 1 of the "top arrow" layer. Add the scripting as shown below. In the Actions window, choose *Actions->onClipEvent*. Select the EnterFrame checkbox. Choose *Actions->if* and type in "pressing && _parent.assets._y<0" in the Condition field. Next, choose *Actions->Evaluate* and type in "_parent.assets._y += 10;" into the Expression field.

7. Select the movie clip in frame 1 of the "bottom arrow" layer. The code will look exactly like the other arrow's code but with minor changes: _y>**-58**) and _y -= 10.

```
onClipEvent (enterFrame) {
  if (pressing && _parent.assets._y>-58) {
  _parent.assets._y -= 10;
  }
}
```

The condition of the if statement asks that the y position be greater than -58 pixels in order for the position to be changed, and 10 pixels are subtracted from the "assets" movie clip y position in each update rather than adding to it.

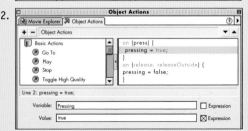

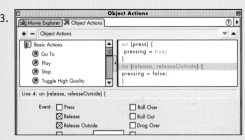

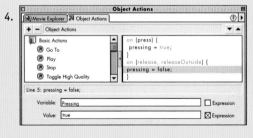

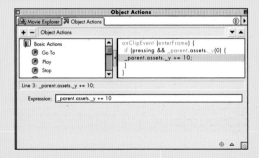

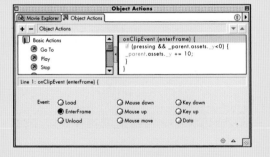

Mask and Masked Layers

A Mask layer is shown within the layers list signified by a white circle and a red downward-facing arrow. This arrow shows that the layer just beneath will be masked against the image placed on the layer above. This means that the lower image will be viewable only through the area designated as a mask in the above layer.

The Masked layer appears in the layers as a purple circle and a white angled arrow. This layer holds the object or image that will be masked through the image above.

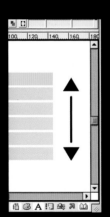

While still in the "all Scroll MC" movie clip, select the first frame in the "line" layer and draw a vertical line between the two arrow heads as shown above.

Next, the animations will be created for the arrow up and down movement.

Select frame 5 in the "bottom arrow," "top arrow," and "line" layers and insert a key frame using the *F6* key. Select frame 10 in all three layers and insert another key frame. Select the arrow key frames at frame 5 and drag them together on the Stage as shown above. Click in the "top

arrow" layer and choose *Insert->Create Motion Tween*. The arrows show the motion of the animation. Repeat the motion tweening for "top arrow" and "bottom arrow" layers. Resize the line in the "line" layer at frame 5 and animate this object as well.

Creating the Main Timeline Animation

1. Return to the main Timeline and select frames vertically in frame 10. Click and drag down in the first six layers: "actions," "labels," "top txt," "bott txt," "url butts," and "graphics." Press the *F6* key to insert key frames in the selected layers. Repeat this process at five-frame intervals: 15, 20, 25, 30, 35, 40, 45, 50, 55.

2. Select frame 10 in the "actions" layer and insert a Stop action using *(+)->Basic Actions->Stop* from the Object Actions window. Copy this action and Paste it at five-frame intervals to match the key frames previously inserted above.

3. Choose *Window->Panels->Frame*. Select the first frame in the "labels" layer on the Timeline and in the Label field of the panel, type a lowercase "a." Repeat this on at five-frame intervals, as shown right. Be sure to name each label "a"–"j."

4. Select frame 10 in the "url butts" layer. Drag an instance of the "Invisible Button" to the Stage. Using the Info panel, set the x position at 311 and y position at 298. Select the button on the Stage. Choose *Window->Actions*, and in the Object Actions window select *(+)->Basic Actions->On Mouse Event* and leave the defaults checked. Next, select *(+)->Basic Actions->Get URL*. Type a full Web address in the URL field, ie.: http://www... . With this script on the button, it can now be copied and pasted in place for each five interval key frame, and only the URL field needs to be changed for each.

5. Select frame 10 in the "graphics" layer and drag a copy of a graphic (size should be 275 by 275 pixels) on to the stage. Position this graphic at 323 x and 111 y. Repeat this to place graphics in key frames at five-frame intervals.

6. Select the "bott txt" layer and type Web address for each button in the Timeline. Select the "top txt" layer and insert a header title for each fifth frame. Place the header text as shown below right.

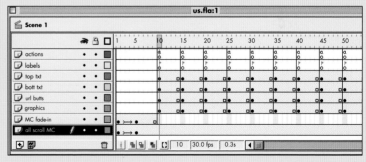

7. To create a fade-in of graphic elements, select the frames of any elements that will fade-in and *Copy->Paste in Place* the elements in the "MC fade-in" layer. Be sure to make the selected elements a movie clip symbol by pressing *F8*.

8. The final step is to publish the movie. Be sure the "us.swf" movie is in the same folder/directory as the "main.swf" movie. Test the movie by opening the "main.swf" movie and checking that the buttons and scrolling text work, as well as the get URL actions.

< User Interaction: Creating Forms >

Flash is capable of doing a lot more than animating characters or moving type and logos across a screen. Flash's scripting capabilities offer designers and programmers the ability to implement external applications that can enhance a project's functionality and usability. PHP programming is one of the programming applications that many Flash developers are beginning to use to produce sites that are dynamic and mesh with the Web.

The Popsicleriot project shown here features a contact form created in Flash. The programming also incorporates a PHP script that handles the Flash form.

This tutorial shows how to build the Flash form and the Submit button, and also shows how to use the PHP script and make minor adjustments to it for use in a Flash Web site.

To complete this tutorial, the reader should know how to: work with toolbox tools and modifiers, symbols and instances, text options, the timeline, and a HTML text editor.

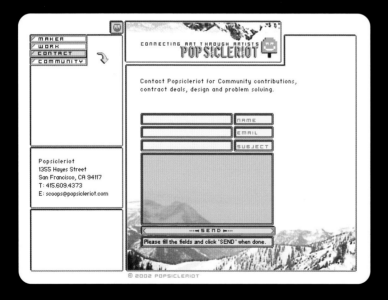

Popsicleriot Portfolio Web Site

Project Popsicleriot Portfolio
Design Firm Popsicleriot
All Design David Richard
Scripting David Richard, www.ultrashock.com
Software Adobe Photoshop, BBEdit,
. SoundEdit 16
Country U.S.A
URL www.popsicleriot.com

PHP Script

This project involves two files, the Flash .swf file that will be created at the end of the tutorial, and a PHP script named php_mail.php3 that handles the Flash form's mailing process. PHP is a general-purpose scripting language that is well suited for Web development and can be embedded into HTML.

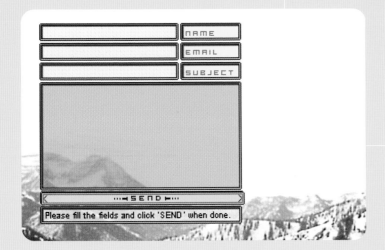

The Popsicleriot Flash portfolio was created using Adobe Photoshop, Flash, and PHP scripting. The main interface, including all of the yellow-stroked form boxes, were created as transparent .png files exported from an external application and imported into the Flash project.

(Notice the mountain JPEG graphic showing through the form's main text box in the background of the image above.) The project's interface can also be created directly in the Flash program, but the bevels and rounded corners may not look as clean.

For this project, create an interface similar to the one shown above. If a transparent .png is preferred to a Flash-drawn interface, see page 33 (Creating and Exporting a Transparent .png File from Adobe Photoshop).

The first step is to create a new movie file 640 pixels wide by 450 pixels in height. The background will be white and the Frame Rate will be 60 fps.

Selecting a Variable Action

To choose the Set Variable, open the Actions window and use the *(+)->Actions->set variable* hierarchical menu to select the action. When scrolling through a long line of actions, this will be faster than double-clicking and scrolling through the blue arrows in the Frame Actions window.

2

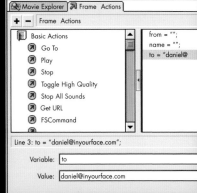

After creating the new movie file, add four new layers to the already existing "Layer 1." Name these five layers from top to bottom: "actions," "send button," "form boxes," "body," and "text."

Next, select the first frame in the "actions" layer. Double-click in this frame to bring up the Frame Actions window.

1. Choose *(+)->Actions->set variable*. Type "from" in the Variable field and leave the Value field blank.

Five more variables will be added. 2. Choose *(+)->Actions->set variable*. Type "name" in the Variable field and leave Value blank. 3. Choose *(+)->Actions->set variable* and type "to" in the Variable field. Type an e-mail address in the Value field, such as "daniel@inyourface.com."

4. Choose *(+)->Actions->set variable*. Type "subject" in the Variable field, leave Value blank. 5. Choose *(+)->Actions->set variable*. Type "info" in the Variable field and then type "Please fill in the fields and click 'SEND' when done."

What are Aliased Fonts

The miniml.com aliased fonts are designed to remain crisp and clear (Figure 1), when viewed in Flash. Aliased fonts are particularly useful at small sizes, where antialiasing (Figure 2), can reduce legibility. The aliased fonts used in this project are Hooge and Standard.

Turn to page 142 for more information on the Miniml Flash fonts.

Figure 1

Figure 2

3

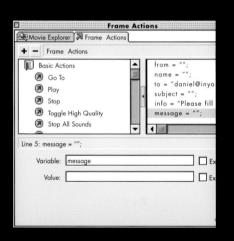

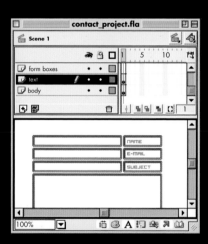

6. Choose *(+)->Actions->set variable*. Type "message" in the Variable field and leave the Value field blank.

Next, select the first frame in the "body" layer and create the interface for the contact form. Use the design supplied on the www.rockpub.com/wtt_flash Web site or

create your own. The interface will need to contain four text input fields, four text description fields, and a Send button.

Create the interface with three long boxes at top, three smaller at right, a large text field box in th middle, and two long boxes at the bottom as shown on the

graphic above. This can be a Flash-drawn interface or a transparent .png graphic imported into Flash.

Next, select the first frame in the "text" layer and create static text boxes for the NAME, E-MAIL, and SUBJECT fields. The font used is the Miniml aliased font,

Hooge_5_53, set at 8 pt. Any font such as Arial or Helvetica will work also. See top of page for more on aliased fonts used in the project.

Using the Text Options Panel

The Text Options panel enables the designer to choose how text is used in the Flash movie. There are three different types of text fields; Static, Dynamic, and Input. The Input text field used in this project allows the user to type directly into the field so that the text can be sent to another source through the use of Flash and PHP scripting.

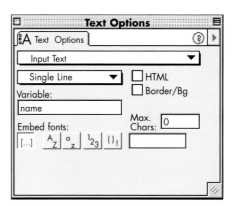

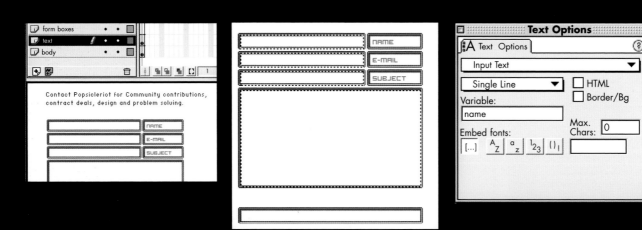

While the first frame of the "text" layer is still selected, type the Popsicleriot intro text as shown above: "Contact Popsicleriot for Community contributions, contract deals, design and problem solving."

Select frame 1 of the "form boxes" layer and create a text box for the longer text input areas to the left of the NAME, E-MAIL, and SUBJECT fields. Click the first text box to highlight it and choose *Window->Panels->Text Options*.

In the Text Options dialog box, choose Input Text from the pull-down menu, choose Single Line from the second pull-down menu, and type name in the Variable field. Click the (Include entire font outline) box [...] located in the lower far left Embed Fonts area.

The font used in the input text fields is another Miniml.com font, Standard 07_56 set at 8 pt.

Embedding Fonts

When a font installed in the system is used in a Flash movie, Flash embeds the font information in the Flash .swf file. This ensures that the font used displays properly in the Flash Player. Keep in mind that not all fonts displayed in Flash can be exported with a movie. To verify that a font can be exported, use *View->Antialias Text* to preview the text. If the type on screen is jagged, this indicates that Flash does not recognize that font's outline and will not export the text.

Turn to page 140 for more information on working with type in Flash.

5

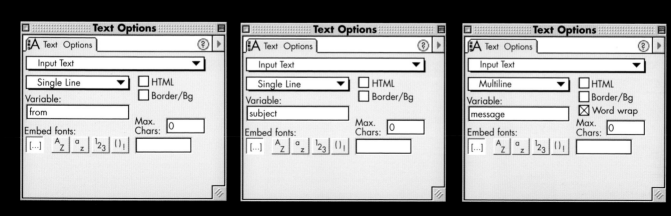

Next, select the second input text field for E-MAIL and follow Text Options for the previous text field. Type "from" in the Variable field.

Select the third input text field for SUBJECT and follow Text Options for the previous text field. Type "subject" in the Variable field.

Select the fourth large input text field for the MESSAGE field. Choose Multiline from the second pull-down menu. Type "message" in the Variable field. For this larger text field, click the Word wrap check box so that the user's text message will wrap correctly.

Be sure that the Embed Fonts icon at the far left is checked for each of the fields.

Using Transparent .PNG files

A transparent .png file can be created and exported from external applications such as Adobe Photoshop. These graphic files can be used in place of vector graphics drawn in Flash, but often add much more to the final K size of the movie.

See page 33 for more information on using .png files in Flash.

6

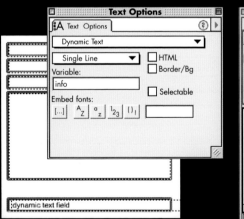
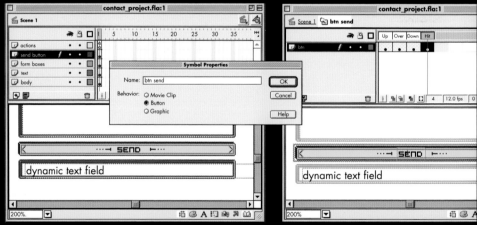

At the bottom of the form, create another text box and in the Text Options dialog box choose Dynamic Text as the pull-down menu, Single Line, and type "info" in the Variable field.

The next step will be to create the SEND button and script it to send the form to be processed.

Select frame 1 of the "send" layer. Draw a box in the blank area between the message field and the dynamic text field. Use the Rectangle Tool or a transparent

.png to create the button. Create a text box and type "SEND." Place this text in the center of the button.

Select the graphic and text on the Stage and press the *F8* key to bring up the Symbol Properties. Select Button as the Behavior.

Double-click the button to open the edit button mode. Change the button to have Up, Over, Down, and Hit states for user interaction.

Scripting the Send Button

The ActionScript code for the SEND button is extensive and needs to be explained. Use the Expert mode to either copy and paste the code from the Flash project located at the www.rockpub.com/wtt_flash Web site or type the code as shown in the example shown here.

1. Select the Send button on the Stage. Choose *Window ->Actions*. In the Object Actions window, choose the options arrow from the top right of the window and change the option from Normal Mode to Expert Mode.

Copy the code from the downloaded Flash project or the text file supplied online. Paste the code into the Object Actions scripting window.

Another file that will be needed is the "php_mail.php3" file (shown below), also supplied as a downloadable file from the rockpub.com Web site.

The following pages describe the script and what the various lines of code do when used in Flash.

Object Actions window

Movie Explorer | Object Actions

Object Actions

```
on (release) {
    if (name eq "") {
        info = "Please enter your name";
    } else if (from eq "") {
        info = "Sender e-mail field blank ?";
    } else if (to eq "") {
        info = "Please enter destination address";
    } else if (subject eq "") {
        info = "Please enter something in the subject box!";
    } else if (message eq "") {
        info = "Please enter some text in the message box!";
    } else {
        leng = length(from);
        n = "1";
        while (Number(n)<Number((leng-1))) {
            if (Number(ord(substring(from, n, 1))) == 64) {
                ok1 = "1";
            }
            if (Number(ord(substring(from, n, 1))) == 46 and Number(ok1) == 1) {
                ok2 = "1";
            }
            n = Number(n)+1;
        }
        leng = length(to);
        n = "1";
        while (Number(n)<Number((leng-1))) {
            if (Number(ord(substring(to, n, 1))) == 64) {
                ok3 = "1";
            }
            if (Number(ord(substring(to, n, 1))) == 46 and Number(ok1) == 1) {
                ok4 = "1";
            }
            n = Number(n)+1;
        }
```

```
(ok1)+Number(ok2)) == 2) {
ber(ok3)+Number(ok4)) == 2) {
?name=" add name add "&from=" add from add "&to=
th = length(url_string);

er(num)<=Number(u_length)) {
ber(ord(substring(url_string, num, 1))) == 32) {
        url_full = url_full add "+";
f (Number(ord(substring(url_string, num, 1))) == 7 or
    url_full = url_full add "%0D%0A";
{
        url_full = url_full add substring(url_string, num, 1);

Number(num)+1;
```

php_mail.php3

```php
/*How many times at a stretch visitor can send mail using the script (2 times default)*/
$opss = 50;

/*And after what amount of time allow that visitor to send mail again (1 hour default)*/
$ok = 3600;

$php_header = "From: $name <$from>\n". "X-Mailer: Mike Franklin Online";
$antispam = $HTTP_COOKIE_VARS["times"];
$message_tosent=$message."\n\n send by $REMOTE_ADDR.";
if ($antispam < $opss){
setcookie("times",$antispam+1,gmdate(time()) +$ok);
if (@Mail($to, $subject, $message_tosent, $php_header)){
echo "&info=Mail sent. Thank you. A confirmation email will be sent. &";
$confirm_to = $name . "<$from>";
$confirm_header = "From: YourName<you@yourSite.com>";
$confirm_message = "Your message has been sent. \nTo: $to\nSubject: $subject\n";
$confirm_subject = "Email Confirmation";
@mail($confirm_to,$confirm_subject,$confirm_message,$confirm_header);
}else{
echo "&info=Error. Please try later.&";
}
}
else{
echo "&info=Sorry. Spamming not allowed here.&";
}

?>
```

Page 1 | Sec 1 | 1/2 | At 1" | Ln 1 | Col 1 | 0/437 | REC TRK EXT OVR

Scripting the Send Button

1. The first piece of code begins with the `on release` of the mouse on the button and creates a conditional statement that asks `if` there is anything typed in the `name` text field. If the `name` text field is empty, the `info` text field will read: "Please enter your name."

```
1.
                                                              ▼  ▲
  on (release) {
    if (name eq "") {
      info = "Please enter your name";
```

2. This code accomplishes a similar task with an `else if` statement. This time it checks to see if the FROM, TO, SUBJECT, and MESSAGE text fields have been filled out. If they are empty, the INFO text field prompts the user to fill them out.

```
2.
  } else if (from eq "") {
    info = "Sender e-mail field blank ?";
  } else if (to eq "") {
    info = "Please enter destination address";
  } else if (subject eq "") {
    info = "Please enter something in the subject box!";
  } else if (message eq "") {
    info = "Please enter some text in the message box!";
```

3. This code detects a correct e-mail address when the user fills in the form text field.

```
3.
  } else {
    leng = length(from);
    n = "1";
    while (Number(n)<Number((leng-1))) {
      if (Number(ord(substring(from, n, 1))) == 64) {
        ok1 = "1";
      }
      if (Number(ord(substring(from, n, 1))) == 46 and Nu
        ok2 = "1";
      }
      n = Number(n)+1;
    }
```

4. This code ensures that the e-mail address that was typed into the variable `to` is the same e-mail address that is listed in the php_mail.php3 file.

```
4.
    leng = length(to);
    n = "1";
    while (Number(n)<Number((leng-1))) {
      if (Number(ord(substring(to, n, 1))) == 64) {
        ok3 = "1";
      }
      if (Number(ord(substring(to, n, 1))) == 46 and Numb
        ok4 = "1";
      }
      n = Number(n)+1;
    }
```

Scripting the Send Button

5. This code formats information to be read by the php script and then loads the specific variables to the php_mail.php3 file with the information.

6. The final change needs to be done in the php script. Open the php_mail.php3 file and change the "you@yoursite.com" to the destination e-mail address that will be used to receive information sent from the form.

5.

```
if (Number(Number(ok1)+Number(ok2)) == 2) {
    if (Number(Number(ok3)+Number(ok4)) == 2) {
        url_string = "?name=" add name add "&from=" add
        u_length = length(url_string);
        num = "1";
        url_full = "";
        while (Number(num)<=Number(u_length)) {
            if (Number(ord(substring(url_string, num, 1))
                url_full = url_full add "+";
            } else if (Number(ord(substring(url_string, nu
                url_full = url_full add "%0D%0A";
            } else {
                url_full = url_full add substring(url
            }
            num = Number(num)+1;
        }
        loadVariablesNum ("php_mail.php3" add url_full, 0);
        info = "Thank You!";
    } else {
        info = "Please check destination e-mail address form
    }
} else {
    info = "Please double-check your e-mail address format";
}
ok1 = "0";
ok2 = "0";
ok3 = "0";
ok4 = "0";
}
```

6.

```
php_mail.php3

/*How many times at a stretch visitor can send mail using the script (2 times default)*/
$opss = 50;

/*And after what amount of time allow that visitor to send mail again (1 hour default)*/
$ok = 3600;

$php_header = "From: $name <$from>\n". "X-Mailer: Mike Franklin Online";
$antispam = $HTTP_COOKIE_VARS["times"];
$message_tosent=$message."\n\n send by $REMOTE_ADDR.";
if ($antispam < $opss){
setcookie("times",$antispam+1,gmdate(time()) +$ok);
if (@Mail($to, $subject, $message_tosent, $php_header)){
echo "&info=Mail sent. Thank you. A confirmation email will be sent. &";
$confirm_to = $name . "<$from>";
$confirm_header = "From: YourName<you@yourSite.com>";
$confirm_message = "Your message has been sent. \nTo: $to\nSubject: $subject\n";
$confirm_subject = "Email Confirmation";
@mail($confirm_to,$confirm_subject,$confirm_message,$confirm_header);
}else{
echo "&info=Error. Please try later.&";
}
}
else{
echo "&info=Sorry. Spamming not allowed here.&";
}

?>
```

```
$confirm_header = "From: YourName<you@yourSite.com>";
```

Page 1 Sec 1 1/2 At 1" Ln 1 Col 1 0/437 REC TRK EXT OVR

Navigation

Hendri Soerianto's portfolio tutorial shows how he created the buttons and the scripting that makes the buttons dynamically follow along with the cursor, as well as slide upward from the bottom of the navigation bar.

~

The Butte College Web tutorial shows how to draw a map using Flash drawing tools, create a rollover for the building information, and add a pop-up list that offers users rollover interaction for finding information.

~

The Emu Lander tutorial describes how the designers and programmers created the keypad navigation of the project and how the scripting for the gravity of the Emu was written.

Button Rollovers

Soerianto Online Portfolio

88

Creating an Interactive Map

Butte Community College

106

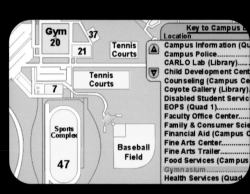

Using the Keypad

Look and Feel New Media Online Game

118

Hendri Soerianto's portfolio features a bottom navigation bar consisting of small, thinly outlined rectangular buttons. Each button has a rollover attached to it that pops up a small thumbnail of the larger image that can be seen when the button is clicked.

This tutorial shows how Soerianto created the buttons and the scripting that makes the buttons dynamically follow along with the cursor, as well as slide upward from the bottom of the navigation bar.

To complete this tutorial, the reader should know how to: work with toolbox tools and modifiers, the Action window, symbols and instances, the Timeline, and the Info panel.

Hendri Soerianto's Mini Portfolio

Project Hendri Soerianto's Mini Portfolio
All Design Hendri Soerianto
Scripting Hendri Soerianto
Software Adobe Photoshop, Macromedia Fireworks,
. Macromedia Dreamweaver
Country Singapore/Indonesia
URL www.soerianto.net

Button Rollovers

The button rollovers shown in this tutorial feature two different elements; a crosshair icon on the small boxes, and small photographic images for the main thumbnails.

There are several elements in Hendri Soerianto's portfolio that add to the overall experience of viewing the design projects it features. In this tutorial, we'll describe and show step by step how to create the bottom navigation bar used throughout.

The first step is to create a new movie 300 pixels wide by 400 pixels high. Change the Frame Rate to 31 fps, and keep the background white.

Rename the "Layer 1" frame to "thumbs_all."

Press the *Command-F8* keys to bring up the Symbol Properties dialog box, type "thumbs_all" as the Name, and select Movie Clip as the symbol. Click OK.

Creating a new movie clip in this way opens the movie clip directly to the editing mode. Notice the hierarchy of the Timeline just above the layers area that shows the "Scene 1" and "thumbs_all" movie clip icons (above).

Actions Layer Code

The first code for the frame 1 "actions" layer reads:

```
setproperty (threed12, _alpha, 40);
_root.boxname = threed12;
_root.startRoll = true;
```

This initial code sets the crosshairs to the first rollover box, as shown at right with the hand icon on top of the small box.

Create and name five layers starting from the bottom up: "action clip," "boxes," "rollover," "pointer," and "actions."

Click in frame 1 of the "actions" layer. Choose *Window->Actions* to open the Frame Actions window.

Choose *(+)->Actions->set property*. Set the pull-down menu to Alpha. In the Target field, enter "threed12," and in the Value field, enter "40."

Next, choose *(+)->Actions->set variable*. In the Variable field, type "_root.boxName." In the Value field, type "threed12," and select the Expression checkbox.

Choose *Actions->set variable*. In the Variable field type "_root.startRoll" and enter "true" in the Value field. Select the Expression checkbox.

The Info Panel

Use the Info panel to change the x and y coordinates of a specific object on the Stage. It can also be used to set an exact height and width for each object.

Select frame 1 of the "pointer" layer and, using the Rectangle Tool from the toolbar, draw an 11-pixel-square box with a hairline stroke and no fill.

Choose *Window->Panels->Info*. Select all four sides of the square by double-clicking on one of the strokes. In the Info panel, change width to 11 and height to 11 to create a perfect square that 11 pixels on each side.

Change the color of the stroke to #999999 gray using the color picker.

Next, select the Arrow Tool and drag across the middle and top areas of the box and press delete. This will create the crosshair image as shown above.

Choosing Which Symbol to Use

There are three different symbols that can be used in
Flash projects. These are: movie clip, button, and graphic.
A button typically is used when a rollover element is needed
on the Stage. A graphic is used for static elements on the
Stage, and a movie clip is used for animating an instance on
the Stage.

An animated movie clip symbol that has been dragged to the
Stage from the library will not show when in play mode. To
see an animation the movie clip must be tested in order
to be viewed.

4

Select the full crosshair image
and press the *F8* key. In the
Symbol Properties dialog box that
pops up, select Movie Clip as the
Behavior, name it "pointer," and
click OK.

Make sure the pointer movie clip
is selected on the Stage and
choose *Window->Panels->
Info*. Change the x and y positions
to 0 to zero out the registration
of the pointer. Choose
Window->Panels->Instance and
type "pointer" as the instance.
Select frame 1 of the "boxes"

layer. Use the Rectangle Tool to
draw a gray box (#99999) with no
fill and a hairline stroke.

Using the Info panel, change the
box size to 7.5 pixels wide by 7.5
pixels high.

Select the gray box and press *F8*.
Select Button as the Behavior and
name it "btn_thumb." Click OK.

Double-click the button to enter
the button editing mode.

Button States: Animated Buttons

Movie clips animate in single frames when dragged from the Library onto the Stage. Because they only animate in a single frame, they are ideal for placing into the Over state of a button. An animation placed in the Over state will play when the user rolls over the button with a cursor.

5

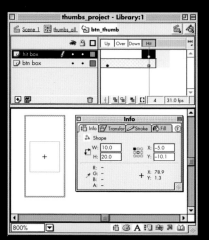

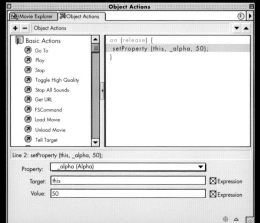

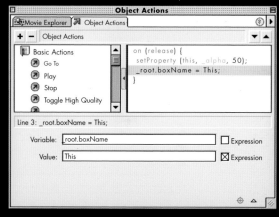

In the button edit mode, rename "Layer 1" to "btn box." Click in the Hit state and press *F5* to fill the frame. Create a second layer and name it "hit box." Click in the Hit state and insert a new key frame by pressing *F6*. Use the Rectangle Tool to draw a red rectangle 10 pixels wide by 20 pixels high. Use the Info panel to

change the width and height to the exact dimensions.

Drag the rectangle so that it is centered on the plus sign registration point as shown above left.

Return to the "thumbs_all" Timeline to script the button. Select the "boxes" button on the Stage and choose *(+)->Actions*. Choose *Actions->on* and leave "Release" checked. Choose *(+)->Actions->Set Property*. In the pull-down menu select Alpha and type "this" in the Target field.

Type "50" in the Value field. Select both of the *Expression* checkboxes.

Choose *(+)->Actions->set variable*. "Type _root.boxName" in the Variable field. Type "This" in the Value field. Be sure to select the Expression checkbox for the Value field only.

The _root Variable

If a movie has multiple levels, the root movie Timeline is on the level containing the currently executing script. For example, if a script in level 1 evaluates _root, level 1 is returned.

Specifying _root takes the place of using the slash notation (/) to specify an absolute path within the current level.

6

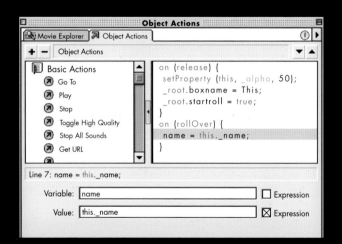

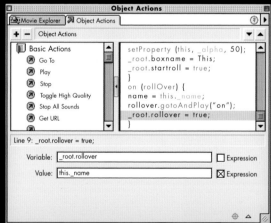

Choose (+)->Actions->set variable and type "_root.startroll" in the Variable field. Type "true" in the Value field. Select the Expression checkbox for the Value field.

Select the last curly bracket and choose (+)->Actions->on. Deselect the Release Event and select Rollover Event. Choose (+)->Actions->set variable. Type "name" in the Variable field and "this._name" in the Value field. Select the Value Expression checkbox.

Choose (+)->Actions->evaluate. and type "rollover.gotoAndPlay("on")" in the Expression field. Choose (+)->Actions->set variable. Type "_root.rollover" in the Variable field, and type true in the Value field.

Be sure to select the Expression checkbox in the Value field.

Registration of an Object

There are many times when an object in Flash will need to be registered to another object for positioning or set to a specific location for rotation, transformation, or reference to another object.

To set an object to a specific area of the Stage, click one of the small squares in the Info panel (usually upper left or center) and change the x and y positions.

7

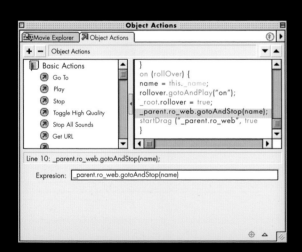

Choose *(+)->Actions->evaluate*.
Type "_parent.ro_web. gotoAnd stop(name)" in the Expression field.

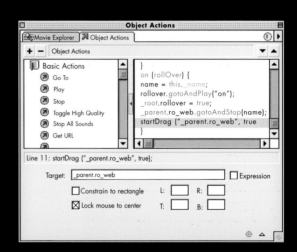

Choose *(+)->Actions->start drag*.
Type "_parent.ro_web" in the Target field. Select the Lock mouse to center checkbox.

Reistration Points in an Object

To change the registration point in an object, select an object on the Stage and choose *Modify->Transform->Edit Center*. Select the small registration mark (+) and move it to another area of the object. This is often used for changing the rotation point of an object.

8

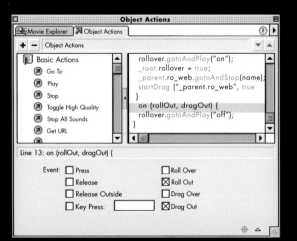

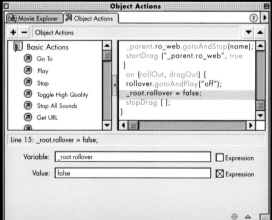

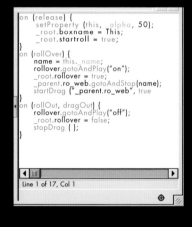

Select the last curly bracket and choose *(+)->Actions->On*. Deselect the Release Event and select the Roll Out and Drag Out Events. Choose *(+)->Actions->Evaluate*. Type "rollover.gotoAndPlay('off')" in the Expression field.

Choose *(+)->Actions->set variable*.

Type "_root.rollover" in the Variable field and "false" in the Value field.

For the final piece of code choose *(+)->Actions->StopDrag*.

The full script for the button is shown above. This script is available for download from a text file at www.rockpub.com/wtt_flash.

Transform

Use the Transform panel to change the size of an object. If the dimensions of the object need to be reduced equally to create symmetrical sides, be sure to click the Constrain checkbox before changing the percentage of reduction or enlargement.

9

Select the button on the Stage and press *F8* to convert it to a movie clip. Select Movie Clip as the Behavior and name it "box_ani."

Next, double-click the button to open it in editing mode. Add two more layers and name them from top to bottom,

"actions," "box," and "rollover." Using the Info panel, set the registration to 0 x and 0 y.

Make sure the button is on the "box" layer. Select frame 1 of the "box" layer and choose *Insert->Create Motion Tween*.

Select frame 5 and insert a new key frame by pressing *F6*. Select frame 1 again and choose *Window->Panels->Transform*. Change the horizontal percentage from 100 percent to 8 percent to create a tall, thin box as shown above.

Select frame 5 of the "actions" layer and insert a key frame using the *F6* key. Double-click in frame 5 to open the Frame Actions window. Choose *(+)->Actions->Stop*.

Stop Actions

To insert a Stop action, select a specific frame in a Timeline layer and open the Frame Actions window. This can be done quickly by double-clicking in the frame. With the Frame Actions window open, use the *(+)->Basic Actions->Stop* in the hierarchical pull-down menu, or double-click the blue arrow icon in the Frame Actions window to show a list of actions. Double-click an action in this list to set an action in the right side of the window.

10

Insert a key frame (*F6*) in frame 5 of the "rollover" layer. Press *Command-F8* for the Symbol Properties dialog box. Select Movie Clip as the symbol Behavior, and name it "box_rollover." Click OK.

In the editing mode for the "box_rollover" movie clip, create

three layers and name them from top to bottom, "actions," "labels," and "box on/off."

Select frames 1, 7, and 16 in the "actions" layer and insert key frames (*F6*). Place Stop actions in each new key frame using the Frame Actions window.

Select frame 2 of the "labels" layer and insert a key frame (*F6*). Repeat this process in frame 8 of the same layer. Select frame 2 again and choose *Window->Labels->Frame*.

Type "on" in the Label field. Select frame 8 and type "off" in the Label field.

Select frame 2 in the "box on/off" layer and insert a key frame (*F6*). Draw a gray box with no stroke. Use the Info panel to make it 7.5 pixels square. Set the x and y positions to 0 to zero out the registration point.

Motion Tweening Shortcut

Move the cursor over the layer where the motion tween will be inserted. Press the Control key while clicking on the layer. This action will bring up a menu with the Create Motion Tween available as the very first option in the pop-up menu.

11

Select the gray box on the Stage and press *F8* to convert to symbol. In the Symbol Properties dialog box select Graphic as the Behavior, name it "boxsm," and click OK.

With frame 2 of the "box on/off" layer selected, choose *Insert->Create Motion Tween*.

Select frame 7 and insert a key frame (*F6*); repeat in frame 15. Select frame 2 in the "box on/off" layer once again and choose *Window->Panels-> Effects*. Use the pull-down menu to select "Alpha" and set transparency to 10 percent. Click in frame 15 of this layer and repeat the Alpha process.

Return to the "box_ani" movie clip by double-clicking on the clip in the Library. Select frame 5 of the "rollover" layer and drag an instance of the "box_rollover" movie clip on to the Stage from the Library. Use the info panel to set the x and y registration to 0.

Return to the main Timeline on

Scene 1 and select frame 1 on the "thumbs_all" layer. Choose *Window->Library* and drag an instance of the "thumbs_all" movie clip on to the Stage. Use the Info panel to set the x position to 40 and the y position to 325. This places the instance at the bottom left of the Stage.

Naming Symbols

One of the quickest ways to get to a specific symbol is to double-click the symbol icon in the Library. It's important that symbols are named as they are created, rather than waiting until they are in the Library, because doing so will make them much easier to find later on.

Name the symbol in the Symbol Properties dialog box rather than clicking OK with the default symbol name.

12

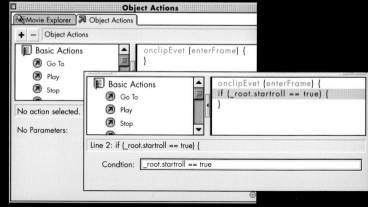

Open the Library and double-click the "thumbs_all" movie clip. Select frame 1 of the "boxes" layer and drag ten instances of the box on to the Stage. Use the Info panel to, set all of the y positions to 2.5 and all of the x positions to the following specifications: 20, 40, 60, 80, 100, 120, 140, 160, 180, 200. Choose the

Instance panel (*Command-I*) and select each of the ten "box" movie clips separately. Name each, starting with "threed12" at the far left and ending with "threed03" on the far right.

Create a new movie clip using *Command-F8*. Name the Behavior "action clip" and click OK.

Return to the "thumbs_all" movie clip by double-clicking it in the Library window. Drag an instance of the "action clip" movie clip from the Library to the Stage. *Choose Window->Actions* to open the Object Actions window.

Choose *(+)->Actions->OnClipevent* and select the EnterFrame checkbox. Choose *(+)->Actions-> if* and type `_root.startroll == true` in the Condition field.

Value Expression Checkbox

Be sure to read the code thoroughly and check the Expression checkbox for Value when it asks for it. If not checked, the script may not read correctly when being processed.

13

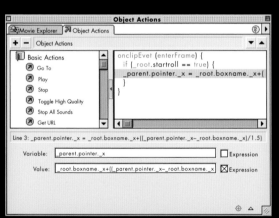

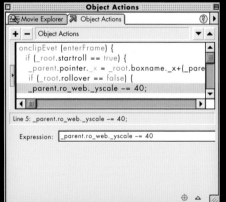

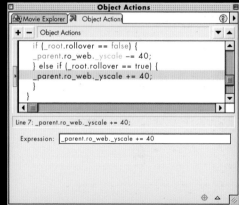

Next, select the if statement that was just entered and choose *(+)->Actions->set variable*. Type "_parent.pointer._x" in the Variable field. In the Value field type "_parent.pointer._x = _root.boxname._x+((_parent.pointer._x-_root.boxname._x)/1.5)"

Be sure to select the Expression checkbox for the Value.

Choose *(+)->Actions->if* and type "_root.rollover == false"

Next, choose *(+)->Actions-> evaluate* and type "_parent.ro_web._yscale -= 40" in the Expression field.

Choose *(+)->Actions->else if* and type "_root.rollover == true". Choose *(+)->Actions->Evaluate* and type "_parent.ro_web._yscale += 40" in the Expression field.

The Rollover Code Nesting Order

```
onClipEvent (enterFrame) {
    if (_root.startroll == true) {
        _parent.pointer._x = _root.boxname._x+((_parent.pointer._x-
_root.boxname._x)/1.5);
    }
    if (_root.rollover == false) {
        _parent.ro_web._yscale -= 40;
    } else if (_root.rollover == true) {
        _parent.ro_web._yscale += 40;
    }
    if (_parent.ro_web._yscale>100) {
        _parent.ro_web._yscale = 100;
    } else if (_parent.ro_web._yscale<10) {
        _parent.ro_web._yscale = 0;
        _parent.ro_web._x = 100;
        _parent.ro_web._y = 500;
    }
}
```

14

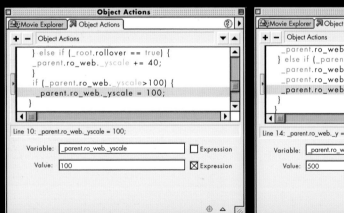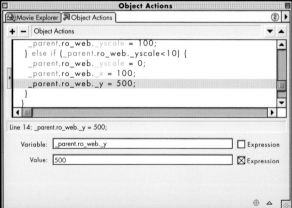

Select the curly bracket below the last piece of code and choose *(+)->Actions->if*. Type "_parent.ro_web._y scale>100". Choose *(+)->Actions set variable* and type "_parent.ro_web._yscale" in the Variable field, and type "100" in the Value field. Select the Expression checkbox.

Choose *(+)->Actions->else if*. In the Condition field type "_parent.ro_web._yscale<10."

The next step is to insert three more variables.

Choose *(+)->Actions->set variable* and for each of the three, type in the following:

Variable:
_parent.ro_web.yscale
Value: 0

Variable: _parent.ro_web._x
Value: 100

Variable: parent.ro_web._y
Value: 500

Select the Expression checkbox for each value field.

In this final code, if the rollover button is activated, the "ro_web" movie clip containing the graphics will begin to grow larger. If the button is rolled off of, the "ro_web" will get smaller.

Using Labels

Labels are used often in Flash for sending the playhead to specific frames in a Timeline. The "threed" labels are used to move the crosshairs icon to specific frames in the "rollover graphics" Timeline.

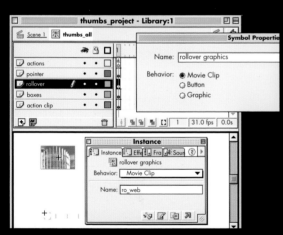

While still in the "thumbs_all" movie clip, select frame 1 of the "rollover" layer and import a bitmap graphic that is 60 pixels wide and 40 pixels high.

Select the bitmap graphic on the Stage and press the *F8* key to Convert to Symbol and bring up the Symbol Properties dialog box.

Select Movie Clip as the Behavior and name it "rollover graphics." Click OK.

Press *Command-I* for the Instance panel. Type "ro_web" in the Name field.

Double-click the movie clip to enter the edit mode.

Rename "Layer 1" to "thumbs" and add four more layers; two above and two below "thumbs." Name the layers from the top down, "actions," "labels," "thumbs," "text," and "shadows."

Select frame 1 of the "actions" layer and insert a stop Action using the Actions window.

Select all layers but the "actions" layer and insert key frames vertically at frames 2, 10, 20, 30, 40, 50, 60, 70, 80, 90, 100, 110, 120. Select each of the new key frames on the "labels" layer and add a label using the Frames panel. Name the labels "threed1," "threed2,"—on up to "threed12."

Inserting the Thumbnails

Import twelve thumbnail images each 60 pixels high by 40 pixels wide. For this project, a single thumbnail image can also be used as a place holder.

Select frame 2 on the "thumbs" layer, and drag a bitmap graphic onto the Stage. Now, select each key frame in the "thumbs" layer and drag a bitmap graphic to the Stage until all key frames have a graphic attached.

If there is an extra image on each layer left over from the original thumbnail image, delete the duplicated images so only one per key frame is showing.

Using the Info panel, register all x and y positions based on the positions listed below. Be sure to select each bitmap image on the Stage before setting the x and y positions.

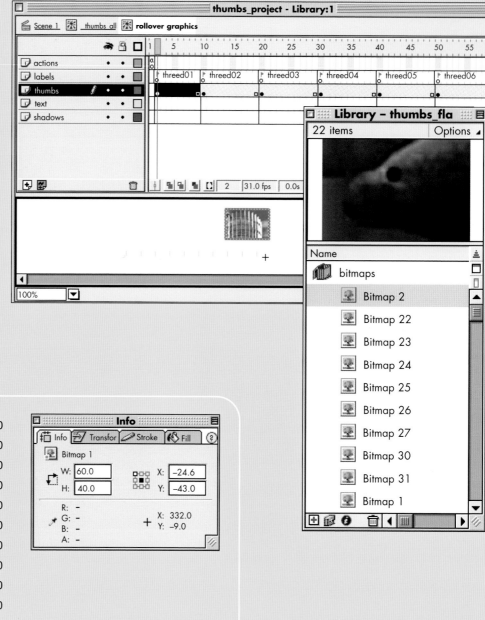

Threed01: X -24.6 Y -43.0
Threed02: X -21.6 Y -43.0
Threed03: X -16.5 Y -43.0
Threed04: X -11.6 Y -43.0
Threed05: X -5.5 Y -43.0
Threed06: X -0.6 Y -43.0
Threed07: X 6.5 Y -43.0
Threed08: X 13.4 Y -43.0
Threed09: X 19.4 Y -43.0
Threed10: X 24.9 Y -43.0
Threed11: X 29.4 Y -43.0
Threed12: X 31.4 Y -43.0

Optimizing Bitmap Images

Use the Bitmap Properties dialog box to optimize JPEG images. Uncheck "Use document default quality" and click the Test button on the right side of the dialog box.

Notice how the 50 percent quality setting reduces the file size of a JPEG dramatically.

Select frame 2 of the "shadows" layer. Double-click the Rectangle Tool to change the Corner Radius to 6. Draw a black box with a stroke 63 pixels high by 43.5 pixels wide. Double-click the box to select it. Use the Info panel to set the exact dimensions of the box and stroke.

Choose *Window->Panels->Mixer*. Select the box and stroke and change the Alpha to 35 percent. This creates a gray box. Select just the stroke and change the Alpha to 11 percent to create a slight blur around the edge of the box. Select this box and convert to a Graphic symbol using *F8*.

Copy this symbol and choose *Edit->Paste in Place* across all key frames in the "shadows" layer. With each box selected after the Paste in Place, use the arrow keys to center them under each thumbnail.

Next, select frame 2 of the "text" layer and insert text below the bitmap thumbnail. Repeat this across all key frames in this layer.

The final step is to double-click on each bitmap graphic in the Library to bring up the Bitmap Properties dialog box. Optimize each graphic as needed.

Flash is a relatively new communication tool, and since many Flash projects include repurposed information from older media sources, Flash has many advantages over printed or static media. The program's interactive and animation qualities will give new life to an old design. The following tutorial shows how to use printed materials—a map of a school campus—to create an interesting and informational interactive tour.

The Butte College Web development team created an online campus map replicating the printed version in the school catalog. The buildings on the map were converted into buttons that highlight offices and activities associated with each. A scrollable list also provides building locations and information alphabetically.

This tutorial shows how to draw the map using Flash drawing tools, create a rollover for the building information, and add a pop-up list that offers users rollover interaction for finding building information.

To complete this tutorial the reader should know how to work with drawing tools and modifiers, button symbols and instances, the timeline, and Object Actions.

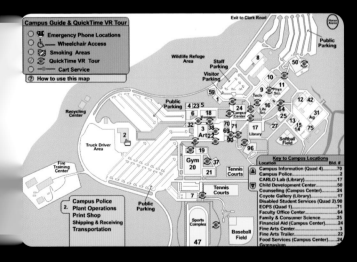

Butte Community College Campus Map

Project	Butte Community College Campus Map
Design Firm	Butte College Web Dev. Team
Design	Jerry Garcia, Carolyn Short
Scripting	Carolyn Short, Jerry Garcia
Production	Carolyn Short
Photography	Carolyn Short
Software	Adobe Photoshop, Macromedia Dreamweaver,
...........	Spin Panormama, Apple QuickTime VR
Country	U.S.A
URL	www.buttecollege.com

Placing Artwork Into Flash

Artwork can be brought into Flash from various graphic programs using the Paste command, dragging and dropping an element on to the Stage, or *Importing from File*. To *Import from File*, choose *File->Import* from the menu or press the *Command-R* keys. In the dialog box, navigate to the file and select it by choosing the Add button and then click the Import button (in Windows click *Open*). Various options exist depending on the program in which the graphic originated. Check out the long list of compatible formats in the Show pull-down menu.

The map used for the Butte College campus map project was scanned at 72 dpi from an 8.5 inch by 11 inch catalog. The map art was optimized and scaled in Adobe Photoshop before being exported as a medium JPEG.

Step 1: Create a new movie. Choose *File->New*. Then choose *Modify->Movie*. In the Movie Properties dialog box, set the width to 800 pixels by 600 pixels in height. Leave all other properties set to Flash's default settings. Click OK.

Choose *File->Import* from the menu or press the *Command-R* keys. In the pop-up window, select a map image to trace and click Add. Once the image has been added to the import window, click Import.

Choose *Modify->Layer* from the menu. Rename "Layer 1" to "map gif," select the Lock option. Set Guide as the layer Type.

Locking a layer prevents an image from being selected or moved. Selecting Guide prevents the image from showing when testing the movie.

Keyboard Shortcuts

Several of the more useful keyboard shortcuts in Flash are simple single-key toolbar shortcuts such as "v" for selecting the Arrow Tool, "m" for selecting the magnifying glass, "r" for selecting the Rectangle Tool, and "t" for selecting the Text Tool.

Other helpful shortcuts to know are "<" and ">" for moving frame by frame through the Timeline, and Command/Control "+" or "-" for enlarging and reducing the Stage.

2

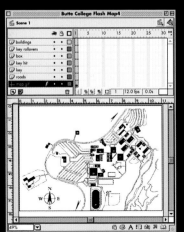

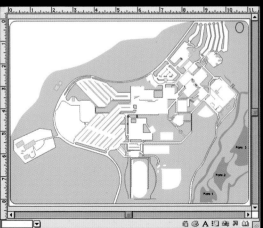

Create six new layers above the "map gif" layer by choosing *Insert->Layer* or clicking the (+) sign at the bottom-left corner of the Timeline. Name the layers, from the bottom up: "roads," "key," "key hit," "box," "key rollovers," and "buildings."

In the Tools Palette, select the Rectangle Tool. Choose the Line and Fill colors by clicking on the color swatches. Choose colors that are easy to differentiate from the map image.

Trace the entire map. Separate the various map elements such as roads and buildings by using new layers.

Be sure to choose the correct layer before beginning to draw the objects. If needed, click on the Show/Hide layer option under the "eye" icon to view separate layers.

Selecting Objects on the Stage

Objects drawn in Flash that have both a fill color and a stroke color can be grouped together or made into symbols. Be sure to double-click an object to select both the line and fill. Clicking once on the fill will only select that area and can leave behind the stroke when making a symbol or when grouping. This could cause trouble later on if the fill and stroke are not combined.

3

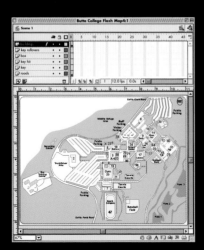

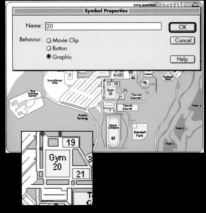

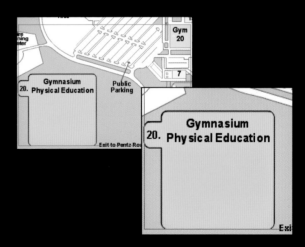

Select the "map gif" layer and delete it from the Timeline. Select the "map gif" symbol from the Library and delete this also. This will minimize the project's file size when it is made into a .swf player file.

Each building will need to be made into a symbol. Double-click the "Gym" building to select it. Press *F8* to bring up the Symbol Properties dialog box. Type "20" and select Graphic as the Behavior. Name each symbol after the title of the building (in this case #20).

Create a box that will be used for information about each building. Double-click the Rectangle Tool to bring up the Rectangle Settings box and set the Corner Radius to 6. This gives the boxes a rounded corner when drawn.

The gym building will be the focus of this tutorial. Duplicate the process for all other buildings on the map.

Paste in Place

Use the *Paste in Place* command when pasting an item that needs to be placed in the exact same area that it was in when copied.

Edit	View	Insert	Modi
Undo			⌘Z
Redo			⌘Y
Cut			⌘X
Copy			⌘C
Paste			⌘V
Paste in Place			⇧⌘V
Clear			Delete
Duplicate			⌘D
Select All			⌘A
Deselect All			⇧⌘A
Cut Frames			⌥⌘X
Copy Frames			⌥⌘C

4

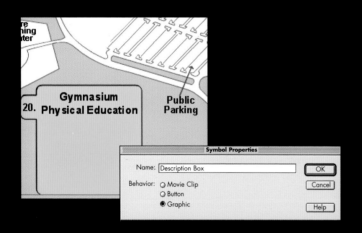

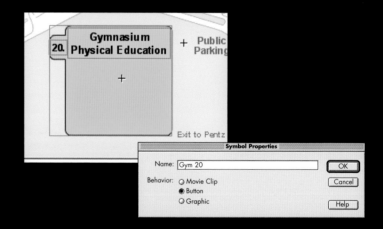

Once the gym information box is drawn, select it, and press *F8* to convert the graphic to a symbol. Name the symbol "Description Box" and select Graphic as the Behavior.

A copy of the "Description Box" will need to be attached to each building featured on the map.

Remember to *Copy* the box and use *Edit->Paste in Place* to paste each one in the exact same place to ensure continuity for the rollovers.

To create the rollover button, select the gym building graphic along with the gym "Description Box" and press the *F8* key. Name the button "Gym 20." Select Button as the Behavior, and click OK.

Learning Key Commands

Time is important when designing a project for yourself, but even more so when designing for a client who will be paying either an hourly rate or a flat fee. To streamline and speed up the design process in Flash or any other program, learn the key commands for each program.

As an example, learn to use the *F8* key to create a New Symbol rather than using the menu bar. Other key commands to know in Flash are *F6* for adding a new Key Frame, *F5* to add a new Frame, and *F7* for adding a blank key frame.

Pressing the *Control-Option* (Mac) or *Control-Alt* (Windows) keys will also pop up menus near the cursor that save time by not having to go to the main menu bar for commands.

5

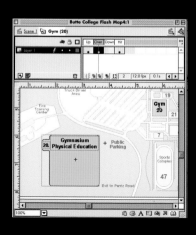 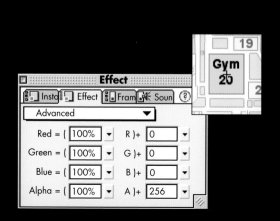 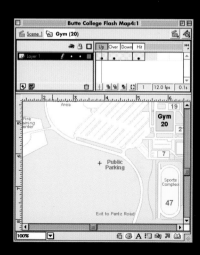

Double-click the "Gym 20" button on Stage to enter the button edit mode. Press *F6* to create a second key frame in the Over state. Click in the Hit state and insert a key frame.

Change the color of the building "Gym 20" graphic in the Over and Down states. Choose *Window ->Panels->Effect*. Use the Tint Color option to change the yellow to a brighter color.

Select the Up state text (not the key frame), then select the "Description Box" on the Stage and delete. Do this for the Hit state also. The graphic will only show on the Over and Down states.

Deleting the "Description Box" graphic from these states will keep the graphic from showing until the user rolls the cursor over the building graphic.

Button Symbols

When a Button Symbol is created, a key frame is automatically placed in the first Up state frame. key frames can be added to the other states by clicking in the frames and inserting a new key frame.

Button states allow a designer to create different actions in a button. Up is normally used as a static element, Over is used for actions when the user rolls the cursor over the button, Down is used when the user clicks on a button, and the Hit state is used to enlarge the clicking area or to create an invisible area of the button.

6

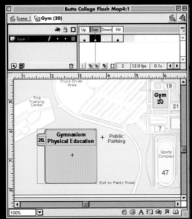

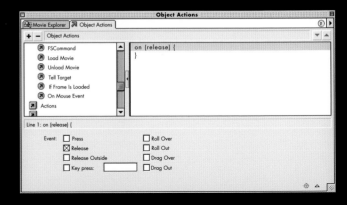

Click in the Over state and add text to the top of the "Description Box."

Name the layer "graphic" and return to the main scene by clicking "Scene 1" in the upper-left corner of the window.

Repeat the Button Symbol steps on all building graphic Symbols within the map.

The building buttons contain basic ActionScript that opens a new Web page when clicked. To add this ActionScript to the button, click on a building with the Arrow Tool to select it.

Choose (+)->*Basic Actions*->*On Mouse Event* action. Under the Event options, select Release.

Optimizing Shapes for Drawing and Tracing

Using the Toolbar

The more information included in a drawing, the larger the Flash .swf file will be when published. There are many ways to optimize graphics for playback performance.

Keep in mind that the Brush Tool's strokes use more memory than pencil strokes. Drawing with the Pencil Tool is recommended.

Solid lines require much less memory than irregular line shapes.

Tools that can be used when optimizing graphics include:

1. Subselect Tool: Use to view and edit a line's points. Keep points to a minimum whenever this is possible.

2. Pen Tool: Use to add and delete points.

3. Smooth and Straighten options:
Take advantage of Flash's Smooth and Straighten options when creating curves and lines. These help eliminate unnecessary points and can simplify shapes.

Object Actions

There are two Action windows that are used when choosing ActionScripts, Object Actions and Frame Actions. When a movie clip or button is selected the Object Actions window appears. The Frame Actions window appears when an action is added to a frame in the Timeline.

Basic Actions

Basic Actions are a prescripted list of actions that Flash makes available for use. These can be found at the top of the Object Actions window and can be used when creating either object or frame actions. There are two ways to access the basic actions; using the scrolling toolbox list on the Object Actions window, or by using the (+) icon to view a hierarchical menu of all actions.

The (-) icon on the toolbox list removes actions from the Actions list. Basic Actions can only be accessed in the Normal Mode. In Expert Mode, Basic Actions is not available.

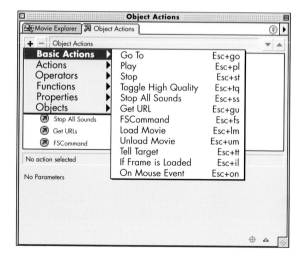

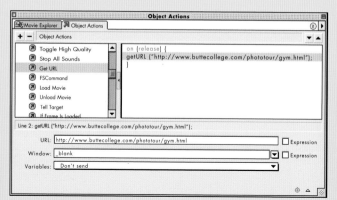

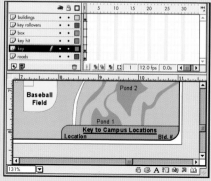

Next, choose (+)->*Basic Actions* ->*Get URL*. Type a Web page address in the URL field. Choose the Window pull-down menu and select _blank. This opens the Web page URL in a new browser window.

This may be all that's required for an informational map; however, it is also helpful to include an alphabetized text listing of all the building names. This project included such a list in a simplified pop-up menu.

Select frame 1 of the "key" layer and begin drawing the top of the key graphic to display how it will look when it is in the lowered position.

Select the key graphic and choose *Insert->Convert to Symbol*. Type "key graphic" as the

name and select Graphic as the Behavior. Make sure the key graphic is still selected and choose *Window->Panels-> Instance*. Select *Button* for the Behavior. This will allow the instance to use Mouse Event actions.

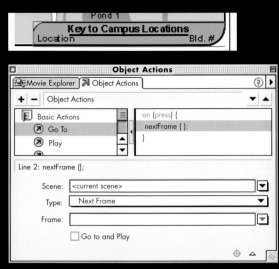

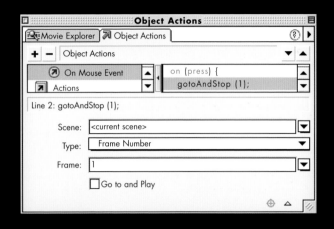

Choose *Window->Actions*. Choose *(+)->Basic Actions->On Mouse Event*.

Deselect the *Release* option box and select *Press*. Choose *(+)->Basic Actions->GoTo*. In the pull-down menu select *nextFrame as* Type.

Select frame 2 "key" layer. With frame 2 still selected open choose *(+)->Basic Actions-> Object Actions*. Use the pull-down menu to change Type to Frame Number. Type a "1" in the Frame field. The code reads:

```
on (press) {
 gotoAndStop (1);
}
```

This code returns the playhead to frame 1 of the map movie when a user clicks the top of the key graphic.

Continuing in frame 2 of the key frame layer, move the key graphic up to make room for the bottom box and text description Box.

Add a bottom box to the key and type an alphabetical list in it.

Creating an Invisible Button

An invisible button is a button symbol that only uses the Hit state, leaving the other states empty. To do this, create a button, edit it by creating a key frame in the Hit state, and then deleting the Up, Over, and Down states. The Hit state doesn't show in the .swf file. In the Flash file, the button will appear on Stage as a turquoise color.

9

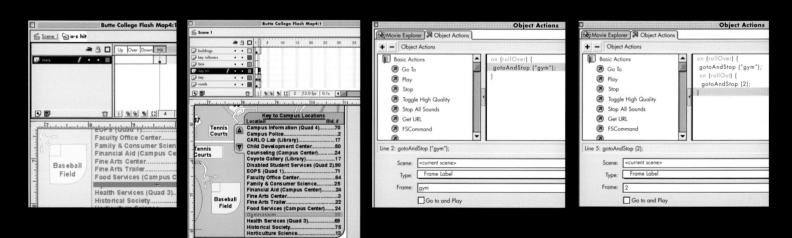

Insert two frames in the "building" and "roads" layers. Click in frame 2 of the "key-hit" layer. Insert a key frame In this layer for creating an invisible button. Draw a box that covers a single line of text in the list. With the box selected, choose *Insert->Convert to Symbol*.

Select Button as the option, name it "invis" and click OK. Open the Library and double-click the "invis" button.

Click in the Hit state and insert a key frame. Click in the Over state and press delete. This removes all visible elements of the button.

Select frame 2 of the "key hit" layer. Drag an instance of the button over each of the lines of text.

Select the "invis" button that is on the "gym" line of text. Choose *(+)->Basic Actions->On Mouse Event* and change Release to Rollover.

Choose Go To and select Frame Label as Type, input "Gym" in the Frame field. Insert On Mouse Event and change Release to Rollout. Choose Go To and select Frame Number, insert "2" in the Frame field.

Simple Testing in Flash

You can test simple buttons and frame actions without previewing or testing the whole scene or movie by selecting the *Enable Simple Frame Actions* and *Enable Simple Buttons* under the Control menu. Use the > and < keys to move forward and backward on the Timeline to test animations.

10

 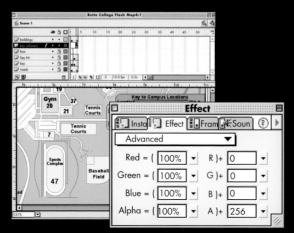 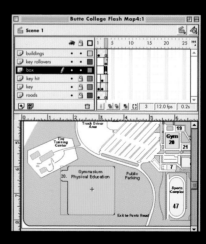

With frame 3 of the "key rollovers" selected, choose *Window->Panels->Frame*. Type "gym" in the Label field.

Change the effect on each graphic mimicking the Over state in the building buttons created previously.

Choose *Window->Panels->Effect*. Drag the Value slider bar on the Alpha input (x A) to 256.

Double-click the "gym" button in the Library. Select and copy the information box from the Over state. Return to the main Scene. Create a key frame in frame 3 of the "box" layer and *Paste* the information box in this frame.

Using the elements described in this tutorial will help when it comes time to create a map project.

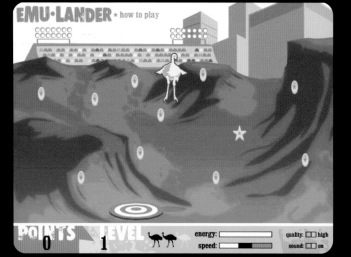

Emu*Lander Game

Project Emu*Lander game
Client Lee Jeans
Design Firm Lookandfeel New Media
Design Travis Beckham
Scripting Travis Beckham
Creative Direction . Charlie O'Shields
Production Kristi Shadid
Sound Bacus Audio & Music
Software Adobe Photoshop, Adobe Illustrator, BBEdit
Country U.S.A
URL www.leedungarees.com/emulander

The Emu Lander

The main focus of this project is the scripting of the emu. The creating of the emu itself is not shown in a step-by-step description. Turn to page 122 to get a breakdown of how the flapping emu was put together and see how to build your own.

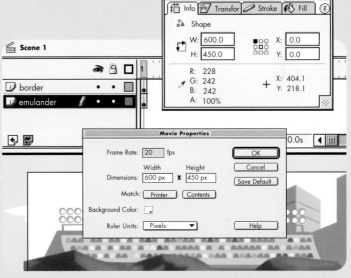

Before beginning the design and production of the Emu Lander project, the designers first created a lunar landscape background image that could be used for the emu to land on. The dirt area was imported as a JPEG image, and the space station was drawn in Flash.

Start by creating a background in either Flash or an image editing program to import into the Flash file.

Next, create a new file in Flash and choose *Modify->Movie* to bring up the Movie Properties dialog box. Set the Frame Rate to 20, change the dimensions to 600 pixels width by 450 pixels in height, and click OK.

Once the background graphic is together on the Stage, be sure to zero out the registration so that all elements align correctly based on this image. Select the image and choose *Window->Panels->Info*. Change the x and y positions to 0 and press the Return key.

Labeling and Creating the Animated Emu

Select each key frame and insert the following labels from left to right: "normal," "up," "down," "left," "right," "crash."

1.

2.

3.

2

Rename "layer 1" to "emulander" and add a second layer. Name the new layer "border." The border layer is optional and can be used to outline the background image.

Select the background image and press the *F8* key to convert to symbol. Select Movie Clip as the symbol and name it "emulander."

Double-click the key frame in frame 1 of the "emulander" layer to enter the edit mode for this movie clip. Rename "layer 1" to "bgrnd" and add a layer. Name the new layer "actions" and double-click in the first frame of this layer to bring up the Frame Actions window.

Choose *(+)->Actions->Emulate*. In the Expression field, type "initGame." This expression will call a function that will be placed on the movie clip later in the tutorial.

4.

5.

6.

3

Next, create the emu movie clip. Press the *Command-F8* keys to bring up the Symbol Properties dialog box. Select Movie Clip as the symbol and name it "emu." Click OK. Create three layers and name them from top to bottom, "actions," "labels," and "player."

Double-click in frame 1 of the "actions" layer to bring up the Frame Actions window. Choose *(+)->Basic Actions->Stop.*

Insert seven key frames in the "actions" and "player" layers. Insert labels into all eight frames following the sequence at top of this spread.

In the "player" layer, build a character similar to the emu sequence shown at top of this page.

The character should have all of the body parts needed to make it look as if it is flying. Once the parts are drawn, select all and copy them into memory. Convert

them to a movie clip symbol (*F8*) called "emu normal." Select frame 2 and choose *Edit->Paste in Place.* Select these parts and Convert to symbol called "emu up." Enter the editing mode for this movie clip, and distribute parts to their own layers for animating the flapping wings.

The Library Window

Expanding the Library window will show that the Library does more than act as a repository for the symbols and names that are created in a Flash movie. Objects can also be viewed as Kind and Date Modified. There is also a Count row that shows how many times a symbol has been used within a movie.

Another important element is the Linkage option, which allows a symbol to be exported along with a movie. An object that has been exported can be positioned on a Stage through scripting, rather than being placed on the Stage graphically. The emu is placed through scripting such that it does not have to start in a position off screen and jump to the middle of the screen when the "initGame" starts the game's action.

4

Repeat the process for creating the emu's "normal," "up," "down," "left," "right," and "crash" positions.

Return to the main Timeline. If an instance of the "emu" movie clip is on the Stage, it should be deleted.

Choose *Window->Library* and select the "emu" movie clip. Select the small options arrow at the top right of the Library window to show the pull-down menu. Select linkage to bring up the linkage dialog box.

Type "player" in the Identifier field and select Export this symbol as the Linkage. Click OK.

When the movie is published, the "emu" movie clip will be exported along with the rest of the movie. This is done so that the "emu" movie clip doesn't have to be hidden off the Stage at the start of the movie.

Inserting the ActionScript Code

There are three ways to input the scripting for the Emu Lander project: 1. Copy and paste the code from the original .fla file located at the www.rockpub.com/wtt_flash Web site. 2. Type the code by hand while reading from the printed version. 3. Use the menu system with the Object Actions window scripting menus.

This project shows how to write the code using the latter option and features a step-by-step tutorial of the process.

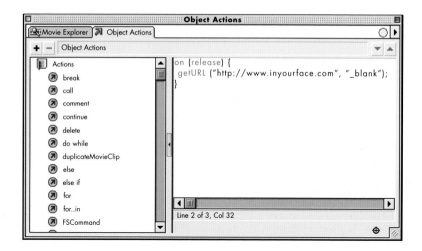

5

Begin by selecting the "emulander" graphic on the Stage in Scene 1.

Choose *Window->Actions* to bring up the Object Actions window. Choose *(+)->Actions->on Clip Event*. Leave the Event set to Load.

Select *Actions->var* and type the following variables. (Select a new *Actions->var* each time.)
```
gameLeft = 60
gameRight = 600
horizon = 380
playerXpos = 295
playerYpos = 65
gravity =.1
onenterframe = null
```

Next, a function brings the emu movie to the Stage. Select *Actions->Function* and type "initGame" in the Name field. Leave the Parameters input field empty.

Select *Objects->movieclip ->attachMovie*. Type "this" in the text just before the `.attachMovie` and replace (idName, newName, depth) with:
`('player', 'player', 200)`

Set Variable

A variable named "container" stores data that may change. Giving the data a name allows Flash to look for the data and retrieve it when needed.

There are three kinds of variables that can be used in Flash: Strings, which can be sequences of characters such as "abcd" or "loop"; numbers such as "10" or "-125"; and Booleans, which are simple true or false values.

The variables set below are Strings. For example "playerXpos" represents the Player's x position (the vertical position of the current object).

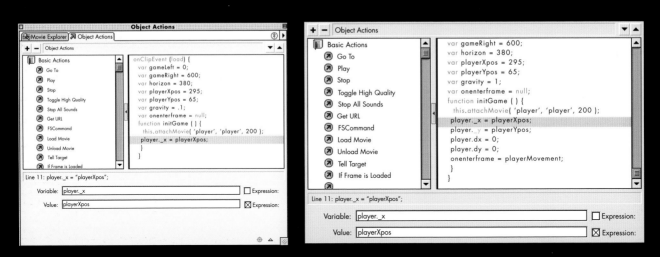

This last element of the function will create variables that position the attached movie and that will be used later in the code to continuously update the movie.

Choose *(+)->Actions->set variable*. In the Variable field type `player._x` and in the Value field type `playerXpos`.

Choose *(+)->Actions->set variable* once again and type:
Variable: `player._y`
Value: `playerYpos`

Insert three more variables using *(+)->Actions-> set variable*.
Variable: `player.dx`
Value: `0`
Variable: `player.dy`
Value: `0`
Variable: `onenterframe`
Value: `playerMovement.`

See the full code on page 133. Be sure the code is typed correctly.

Functions

A function is a set of statements that defines how to perform a certain task. A function can be defined in one location and called from different scripts in a movie. When a function is defined, arguments can also be specified for that function. Arguments are placeholders for values on which the function will operate. A function can pass a different argument—also called a parameter—each time it is called.

```
player._x = playerXpos;
player._y = playerYpos;
player.dx = 0;
player.dy = 0;
onenterframe = playerMovement;
}
function playerMovement ( ) {

}
}
```

7

Next, create a function that controls the movement of the emu player.

Select the lower curly brace and choose *(+)->Actions-> Function*. In the Name field type "playerMovement". Leave the parameters blank.

Highlight the `function playerMovement` and choose *(+)->Actions->if*. Place the cursor in the Condition field, then choose *(+)->Objects-> Key->isDown*. Replace `keyCode` with `key.UP`

Key Movement

The KeyDown and KeyUp scripts instruct the emu character to move up or down from its current position on the Stage.

```
player._x = playerXpos;
player._y = playerYpos;
player.dx = 0;
player.dy = 0;
onenterframe = playerMovement;
}
function playerMovement ( ) {
  if (Key.isDown( key.UP )) {
    player.dy -= .4;
    player.gotoAndStop('up');
  } else if (Key.isDown(keyDOWN)) {
  player.dy += .4;
    player.gotoAndStop('down');
    }
  }
}
```

8

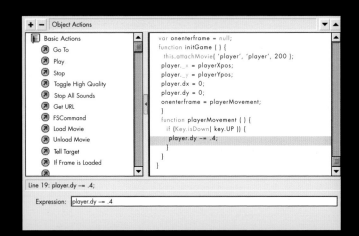

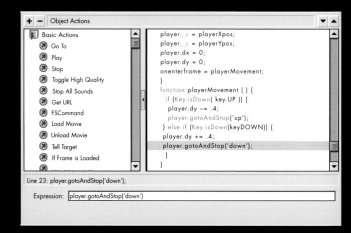

Next, choose (+)->Actions->evaluate and type in the following code in the Expression field:
`player.dy -= .4`

Create a second expression to control the graphics. Choose (+)->Actions->evaluate, and type:
`player.gotoAndStop('up')`.

Choose (+)->Actions->else if. With the cursor in the Condition field choose (+)->Objects->key->isDown and replace `keyCode` with `key.DOWN`.

Add two (+)->Actions->evaluate statements that will control the player movement,
`player.dy += .4`
and
`player.gotoAndStop('down')`

Controlling the Movement

An Else If statement asks if the script is performing a specific function such as `if (Key.isDown)`. If the script is not performing a specific function, it looks to the next piece of script to see what it should be doing.

Emu Right Emu Left

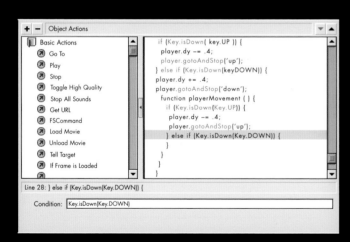

Line 28: } else if (Key.isDown(Key.DOWN)) {

Condition: | Key.isDown(Key.DOWN)

Line 33: player.gotoAndStop('left');

Expression: | player.gotoAndStop('left')

Next, insert two more "else if" statements that control the movie clip movement.

1. Choose *(+)->Actions->else if*. With the cursor in the Condition field choose *(+)->Objects->key->isDown* and replace `keyCode` with `key.LEFT`.

Add two *(+)->Actions->evaluate* statements that will control the player movement, .
`player.dx -= .2`
and
`player.gotoAndStop('left')`

2. Choose *(+)->Actions->else if*. With the cursor in the Condition field choose *(+)->Objects->key->isDown* and replace `keyCode` with `key.RIGHT`.

Add two *(+)->Actions->evaluate* statements that will control the player movement, .
`player.dx += .2`
and
`player.gotoAndStop('right')`

This script contains errors. The errors encountered are listed in the Output Window.

OK

Checking the Code

As the code is being written, check and see if it is correct by choosing the Object Actions pull-down Options arrow in the upper-right corner of the window. From this pull-down menu, select Check Syntax. This checks to see if the code is being input correctly. Incorrect syntax is highlighted red and a pop-up warning box alerts the user.

10

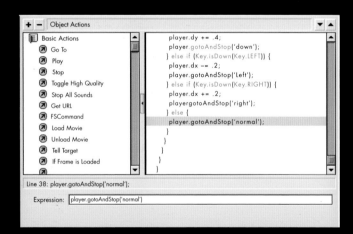

Insert an Else statement. Choose (+)->Actions->else. Insert an evaluate expression. With the cursor in the Expression field, type:
`player.gotoAndStop('normal')`

The final part of the playerMovement function controls what happens when the movie-clip "emu" moves offstage left or right or crashes to the ground.

Select the second } after the ('normal') Expression. Select Actions->evaluate three times and type in the following Expressions for each one.
```
player.dy += gravity
player._x += player.dx
player._y += player.dy
```

Simulating a looping screen

Using ActionScript, the designers programmed the Emu to look as if it is going off the left or right side of the screen and returning on the opposite side. Setting the x (horizontal) position of the Emu allows the script to track where the object is no matter where it is located on the Stage.

11

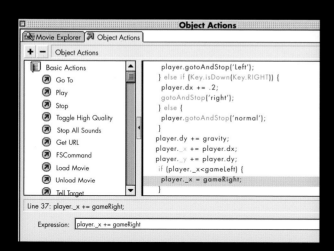

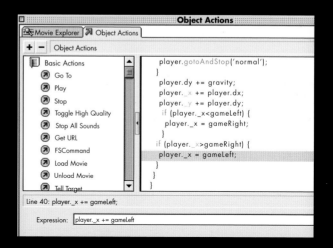

With the `player._y += player.dy` expression highlighted, choose *Actions->if* and in the Expression field type:
`player._x<gameLeft`

Next, choose *Actions->evaluate* and type:
`player._x = gameRight`

This sets the x position of the "emu" movie clip to the right side of the screen if it disappears off the left side of the screen.

Select the next } down from `player ._x<gameRight`, so there will be a space in between the next piece of code. Choose *Actions->if* and in the Conditions field type:
`player._x>gameRight`

Next, choose *Actions->evaluate* and type:
`player._x = gameLeft`

On Enter Frame = Null

Null is a special value that can be assigned to variables or returned by a function if no data was provided when the script references specific data. You can use null to represent values that are missing or do not have a defined data type. The crashing emu is set to null because it no longer needs to be seen as a variable that can move around within the game.

12

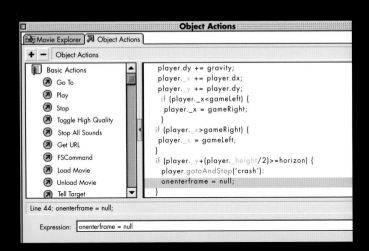

```
player.dy += gravity;
player._x += player.dx;
player._y += player.dy;
  if (player._x<gameLeft) {
    player._x = gameRight;
  }
if (player._x>gameRight) {
  player._x = gameLeft;
}
if (player._y+(player._height/2)>=horizon) {
  player.gotoAndStop('crash'):
  onenterframe = null;
}
```

Line 44: onenterframe = null;

Expression: `onenterframe = null`

```
  if (player._x>gameRight) {
    player._x = gameLeft;
  }
  if (player._y+(player._height/2)>=horizon) {
    player.gotoAndStop('crash'):
    onenterframe = null;
  }
 }
}
onClipEvent (enterFrame) {
onenterframe;
}
```

Line 49: onenterframe;

Expression: `onenterframe`

Select the next } down from `player ._x<gameLeft`, so there will be a space in between the next piece of code.
Choose *Actions->if,* and in the Conditions field type:
`player._y+player.height/2)>=horizon`

Next, choose *Actions->evaluate* and type:
`player.gotoAndStop('crash')`

Choose *Actions->evaluate* and type:
`onenterframe = null`

This final scripting section will update the movie's code continuously.

Choose *Actions->onClipEvent.* Deselect "Load" and select "enterframe."

Choose *Actions->evaluate* and type `onenterframe` to complete the code that is attached to the game movie clip.

The Full Emu Lander Movie Clip Script

The Emu Lander movie clip code shown at right and below can be downloaded from the www.rockpub.com/wtt_flash Web site either as a .fla file or as a text file for pasting into the script.

```
onClipEvent (load) {
    var gameLeft = 0;
    var gameRight = 600;
    var horizon = 380;
    var playerXpos =295;
    var playerYpos = 65;
    var gravity = .1;
    var onenterframe = null;
    function initGame () {
        this.attachMovie('player', 'player', 200 );
        player._x = "playerXpos";
        player._y = "playerYpos";
        player.dx = "0";
        player.dy = "0";
        onenterframe = "playerMovement";
    }
    function playermovement () {
        if (Key.isDown(Key.UP)) {
            player.dy -= .4;
            gotoAndStop ('up');
        } else if (Key.isDown(Key.DOWN)) {
            player.dy += .4;
            playergotoAndStop('down');
        } else if (Key.isDown(Key.LEFT)) {
            player.dx -= .2;
            playergotoAndStop('left');
        } else if (Key.isDown(Key.RIGHT)) {
            player.dx += .2;
            gotoAndStop        ('right');
        } else {
            player.gotoAndStop('normal');
        }
        player.dy += gravity;
        player._x += player.dx;
        player._y += player.dy;
        if (player._x<gameLeft) {
            player._x = gameRight;
        }
        if (player._x>gameRight) {
            player._x = gameLeft;
        }
        if (player._y+(player._height/2)>=horizon) {
            player.gotoAndStop('crash');
            onenterframe = null;
        }
    }
}
onClipEvent (enterFrame) {
    oneneterframe;
}
```

Flash Primer

This section offers Flash beginners a review of tips and techniques for managing Flash projects. It offers intermediate users several quick primers outlining how to accomplish certain processes that are common to most projects.

Flash offers more than one way to handle many of the processes for creating animation, scripting, and interactivity, such as using the menu to insert a motion tween, or pressing the *Control* key while clicking on the frames to be tweened. The following pages offer hints and quick reference to many of the processes. Look in the Resource section for more tutorials and Web-help sites.

Flash Primers

1 Movie Properties

1. Setting the frames per second (fps) in a Flash movie can take some experimenting. For most computer-displayed animations, especially those playing from a Web site, 8 to 12 fps is sufficient. (Twelve fps is the default Frame Rate.) A lower Frame Rate may make the movie play choppily; a faster Frame Rate can make the movie move more smoothly but can increase the file size. Note that many of the project tutorials in this book set the Frame Rate higher rather than lower for smoother playback.

2. The default width for a Flash movie when first opened is 550 by 400 pixels. Be sure to evaluate what size the final movie will need to be. Jumping right into a project without first identifying the objectives and doing rough storyboards and comps can waste a lot of time.

3. Save Default saves the current settings for future files. This is a good option to use if future movies will be the same as the previous.

4. Clicking the Help button will open a browser offline to show the contextual help files for specific areas, such as help in using the Movie Properties dialog box.

5. Clicking on the pull-down menu will show a list of ruler units. Pixels is the default option.

6. Click and hold the background color chip to view the color palette that is used for choosing background colors. The chosen color will be used throughout the project unless changed later.

7. Click the Match Printer button to resize the Stage to the movie's maximum printable area. Click the Contents button to set a 1/4-inch margin on all sides of the project. This option reduces the Stage area to fit around the elements that are currently on the Flash Stage.

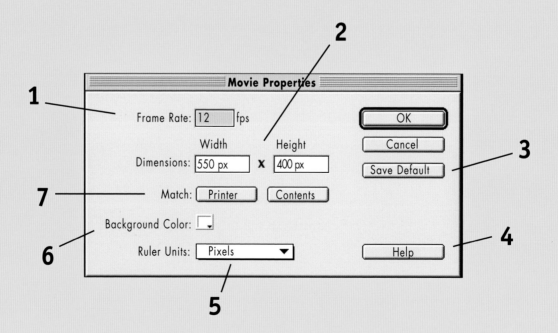

2 | Importing Files

1. Use the *File->Import* or *Command-R* (Mac) or *Control-R* (Windows) to import files into Flash. In Windows, click *Look* and browse to locate a specific file; use the *Add* button for the Mac. Click and hold on the Show pull-down menu to view a list of all formats that can be imported into Flash. The pull-down menu allows the user to select specific file formats, such as only image or sound files.

2. Images can also be brought directly into Flash from another application. Open a program in which an original image has been created—such as Adobe Photoshop—copy the image to the clipboard, and then return back to Flash and Paste the image directly into a selected key frame.

3. Another quick way to bring an image into Flash is to drag an image directly from the Mac Desktop to the Stage of an open Flash file. Be sure that a key frame has been selected in order to place the image on Stage.

4. Vector files can also be imported directly into Flash from Macromedia FreeHand, Illustrator, and a number of other Mac and Windows applications. The Flash import dialog box at right shows the options available when importing from FreeHand. Notice that layered objects created in Freehand or other programs can be imported as layers into Flash, and Flash will automatically place them on individual layers.

3 Animating Symbols

There are three main forms of animation in Flash: motion tweening, shape tweening, and frame-by-frame animation.

1. To create a motion tween, select a frame in the Timeline and insert a key frame using the *F6* key. Draw an object on the Stage or import an object. Select the object and convert it to a movie clip, graphic, or button symbol using the *F8* key. Select a frame farther down the layer and insert another key frame using the *F6* key. Inserting a new key frame duplicates the original object or image.

With the new key frame selected, click on the object or image on the Stage and drag it. Click in the first key frame and use *Insert->Create Motion Tween* from the menu. This animates the object or image between the key frames and shows the animation with an arrow.

2. Shape tweens cannot be made from objects such as movie clip, graphic, or button symbols, grouped objects, text blocks, or bitmap images (e.g., Adobe Photoshop images). To shape tween an object that has been made into a symbol, it must first be broken apart. Text also must be broken apart using *Modify->Break Apart* from the menu. Use the Frame Panel Tweening pull-down menu to add the shape tween. It is distinguished by the green tween color between the two key frames.

Effects that can be applied to Shape tweens include movement across the Stage, color changes, reduction, and enlargement. A shape-tweened object can also have Hints added to it to help morph one area of an object into another. Choose *Modify->Transform->Add Shape Hint*. Add a shape Hint to the beginning key frame and another to the ending key frame to morph from one point to another.

3. The third type of animation is frame by frame. This type of animation is created by selecting a frame and inserting a key frame. Move the image attached to the key frame to a different area of the Stage, and then add another key frame in the next available key frame. Move the object again and insert another key frame. Do this until the full animation is created using multiple key frames.

4 Working with Text Attributes

Flash offers designers many solutions for working with text other than static type. Text can be animated, resized, given transparency, morphed, and colorized. Dynamic text fields can also be created.

1. Select the Text Tool from the toolbar and type a word or sentence on the Stage. Choose *Window->Panels->Character*. The Character panel is used to set the text attributes such as font, type size, color, leading, and tracking. Other elements include the Subscript and Superscript options, an automatic kerning checkbox, and a paragraph tab that offers alignment options for the text, such as left, right, or justified.

2. Type set in Flash can often look blurry or just a bit off when viewed. One way to fix this is to set the type at a zero registration for the x and y positions on the Stage. To do this, choose *Window->Panels->Info*. Select the text object on the Stage, click the small black registration box in the left corner of the registration panel, and type 0 in both the x and y positions. This moves the text block up to the top of the Stage. Refer to the font primer on page 142.

3. In the Popsicleriot E-mail Form tutorial on page 80, the designers use static text, Input Text, and Variables to create the form for sending information through Flash to an e-mail source.

Choose *Window->Panels->Text* to bring up the Text Options panel. The defaut text option is Static. A checkbox also offers a Use Device Fonts option, which can decrease the file size of a movie and increase readability of smaller type. When used, Flash does not use the embedded font (the font chosen for the design) but instead substitutes the device font that most closely resembles the selected font.

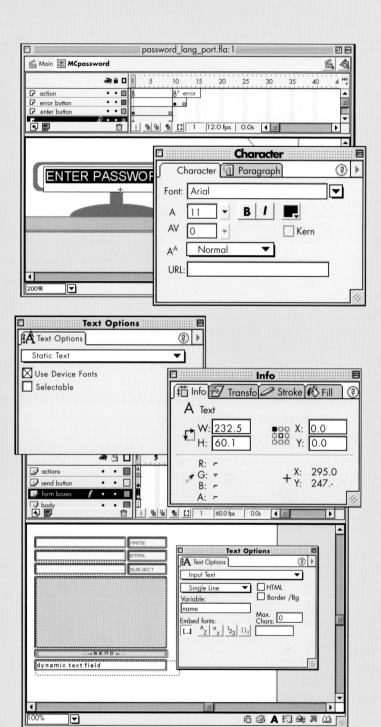

5 Working with Type

Animated typography is one of Flash's most appealing features. Type can be resized, moved, skewed, and rotated. Text can also be made dynamic and used within e-mail contact fields or used along with database programming.

1. Be sure that fonts look smooth on the Stage. If they appear jagged or pixelated, it may mean Flash cannot embed the font being used. Choose another or break the font apart. To use special fills such as gradations, or to add strokes to text, the text must be broken apart.

Once a font is broken apart, it can no longer be edited and the movie size increases. Additionally, once text is broken apart it no longer responds to applied effects such as alpha or tint and must be converted into a symbol to use these effects on the text once again.

2. Use the Text Tool from the toolbar to create a text block on screen. Use the Character panel to resize, color, format, and align the text. Click once on the Stage and begin typing to create a static text box. Click the Text Tool and drag on Stage to create a fixed-width text box. Text will automatically wrap in a fixed-width box. Double-click on the small square handle at the top right of the fixed-width text box to make it a static text box.

3. Flash offers a Device Fonts option that can decrease the size of a movie. When this option is used, Flash does not embed fonts for specific text used in the movie but substitutes the closest device font that resembles the font used. The three device fonts are Sans, Serif, and Typewriter.

6 | Creating and Managing Layers

Layers are the building blocks of Flash. Layers are where all of the elements created or imported into Flash are placed within the Timeline. Remember to plan ahead and create layers for all of the elements that may need to be manipulated separately from each other. A designer rarely creates too many layers but often not enough.

1. Be sure to create a layer for each element. Be aware that any number of objects within a scene may need to be animated, so it's best to add a new layer for every object brought on Stage.

2. Name the layers as soon as they are created. There's nothing worse than receiving a Flash project from another designer who has neglected to name the layers. Much time can be wasted trying to find objects by clicking on the Stage to select them in a layer.

3. Keep in mind that each new layer is created above the previous layer. It's better to plan ahead and place layers where you will need them in the beginning stages of a design, rather than having to move them after the fact.

4. The Layer Properties dialog box is a quick way to change multiple elements of a layer. Double-click the layer icon to open the dialog box, or choose *Modify->Layer* from the top menu.

5. Clicking once on a layer name will select everything on the specific layer. Be sure to check that the correct layer is highlighted before beginning to draw or import an object from the Library. It's easy to just start drawing and then realize later that the object is on the wrong layer.

6. Press the Shift key to select multiple layers at a time. Press *Command* (Mac) or *Control* (Windows) to select layers that are not adjacent to each other.

7 │ Miniml Flash Fonts

The Popsicleriot Web site used a set of fonts called Miniml Flash fonts. Miniml fonts are designed to remain crisp (aliased) in Flash. Aliased fonts are particularly useful at small sizes, where antialiasing can reduce legibility. There are free versions of some fonts at www.miniml.com. These may be used to test and see what can be done with them.

Professional versions of the Miniml fonts are also available for purchase at the Miniml.com Web site. In order for the fonts to work properly you must follow the guidelines Miniml has provided.

1. Miniml fonts must be set to 8 points or any multiple of 8 (16, 24, 32, etc.).

2. Miniml fonts can be used on a vertical axis when they are rotated.

3. Only static text set with Miniml fonts can have adjusted character spacing. Professional Miniml fonts have versions with increased letter spacing for use with dynamic/input text.

4. Dynamic Input Text allows for greater interactivity. The downside is that character spacing can't be adjusted and fonts have to be embedded to display properly on computers that don't have the font installed.

5. Miniml fonts can be used with right alignment easily. Make sure to grab the right corner of the text box to position the text box on the Stage.

6. Use the Snap-to-Pixel feature under View to keep fonts clear. When the font size is not a whole _x and _y values, the fonts will appear blurry.

7. When Miniml fonts are used in motion, round the _x and _y value to the nearest whole value.

The Miniml fonts and the full .PDF version of this explanation can be found at www.miniml.com

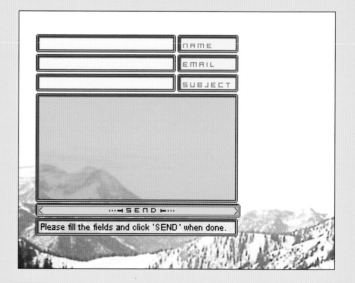

Kroeger 0554

Standard 0753

8 | Using the Timeline

The Flash Timeline is where everything in the Flash movie takes place. It is where all images and drawings are placed for static or animated elements. The Timeline contains the layers for each object that is used within the movie, as well as each individual frame and key frames.

1. In large movies, the Timeline can get in the way if it is taking up too much space at the top of the Stage. Flash allows the Timeline to be moved and redocked to any edge of the Stage, either horizontally or vertically. Click in the blank area above the Timeline and drag away from the top of the Stage to make it into a floating window.

Redock the Timeline by dragging it to one of the edges of the Flash Stage. The Timeline will snap to the edge once it gets close enough.

To prevent the floating Timeline window from snapping to the edge of the Stage and redocking, hold the Control key while moving the window.

The Flash preference settings offer an option to disable docking permanently. Choose *Edit->Preferences* and check the box for Disable Timeline Docking.

2. The Frame View options located at the top right of the Timeline offers various viewing options such as frame size, tinted frames, and a preview option that shows the objects on the Stage visually in each frame in the Timeline.

9 | Using Scenes

Scenes are a way of organizing a Flash movie. Using multiple scenes does not make a Flash movie smaller or play faster. Instead, scenes can make a movie easier to manage, or they can confuse the situtation. If a large movie is being created, such as a Web site, it is often better to use multiple movies rather than multiple scenes.

1. Scenes in Flash play in a linear sequence, one after the other. These scenes can be oraganized and moved from one hierarchical spot to another in the Scene panel.

2. The Scene panel offers the options of creating a new scene by using the (+) icon, deleting scenes with the trash can icon, or duplicating existing scenes with the duplicating icon at the far left bottom of the scene panel.

Scene-related help can be found by clicking on the question mark icon (?) at the top of the Scene panel.

3. Remember that once a scene has been deleted, it cannot be retrieved. Before a scene is deleted an alert box pops up informing that "This operation cannot be undone." Back up Flash files on a regular basis to prevent any loss of information. Hold the *Command* key down when deleting scenes to skip the alert box.

10 Adding Audio and Music

As with any interactive project, adding sound can be either the best or the worst thing that can happen to it. Offering users the option of turning off obnoxious music or repeating button sounds can be an element standing between a return user or an aggravated user.

1. Sounds are imported in the same manner as other graphic objects in Flash. Choose *Import* from the File menu and locate the sound file on the hard drive. Create a new layer and either drag the sound file directly to the new key frame or use the Sound panel to select the sound.

2. The Flash Common Library offers users a selection of basic sounds that can be used in any project for free.

3. Use the Sound panel to manipulate sounds with the Channel and Fade options.

4. Basic sound editing techniques can be accomplished by opening the Edit Envelope from the Sound dialog box. Sound files can be lengthened or faded, and the volume can be manipulated for each channel of a sound file.

5. Sound files can be added to buttons by dragging a sound from the Library into a button key frame.

6. Be sure to select the Sync checkbox to have sounds match the behaviors to which they are attached. Choose Event in the Sync field of the Sound panel pull-down menu to synchronize to the start of an event, "Start" to play a second sound after the first has stoped playing, and "Stop" to end a sound at a specific key frame.

7. Keep in mind that Flash reduces the visual quality of a movie before it reduces the audio quality of a movie when "Stream" is used to sync the sound in the Sound panel.

11 Creating and Using Buttons

Buttons are a powerful element of the Flash tool kit. Remember that a button doesn't always have to look like a button. Using graphics or photos for buttons—rather than falling back on the cliché use of beveled or rounded buttons —can really help the design of an interface.

1. Remember that the Hit state of a button is where a user will click to make an event or action take place. The Hit state is always invisible and can be made larger than the button itself to make clicking on the button element easier.

2. Use the arrow keys on the keyboard to nudge the Down state down a few pixels. The button will look as if it is being pressed by the user.

3. A movie clip can be changed into a button. Choose the Instance panel and select the Behavior pull-down menu to change the Behavior to Button. This will allow the element to be treated like a button for scripting purposes but will not change the element into a button with button states.

Create a Movie Clip symbol and try to add an "On Mouse Event" action to the symbol. It's not highlighted in the Object Actions window and the program will not allow it, but changing the symbol to a Button Behavior will allow the script to be added to the button symbol.

4. Buttons can be used to navigate between Scenes by using the gotoAndPlay action in the Basic Actions window. In the Scene field, choose Scene from the pull-down menu.

5. Select Enable Simple Buttons from the Control menu. This option allows the button to be tested as a working button without having to test the movie. To work on the button, turn Enable Simple Button off.

There are four button states in a button symbol. Double-clicking on a button on the Stage or double-clicking a button symbol in the Library will open the button to the editing mode window. The four states of a button are:

1. Up: Used when the button is on the Stage and no action is being done by the user.

2. Over: Used when a user interaction needs to occur such as a rollover or animation.

3. Down: Used when the user clicks down on the button with the mouse

4. Hit: This is an invisible area that is usually used to create a larger area for the user interaction to occur, such as when a small button is on the Stage and the user needs to be able to get near to make a rollover occur, but not directly on top of the button.

12 Symbols and Instances

Three types of symbols can be used in Flash movies: Movie Clips, Buttons, and Graphics. To keep file size small, reuse symbols multiple times by dragging them directly from the Library. Flash references the original symbol when it is being used.

1. An Instance is any symbol that has been dragged from the Library to the Stage. A symbol's behavior can be changed by using the Instance panel, or by right clicking (Windows), or control clicking (Mac) and selecting the behavior item from the hierarchical menu.

2. There are many times when a symbol's instance will need to be edited in place to see what is happening in relation to other elements on the Stage. The quickest way to do this is to double-click the symbol's instance on the Stage. When this is done, the other elements on Stage will fade out slightly and still show in the background.

3. In order to change the color, alpha transparency, or tint of an object in Flash, the object must first be transformed into a Movie Clip, Button, or Graphic symbol by using Convert to Symbol from the menu. All of these effects can be animated over time through tweening.

4. When an instance's symbol on Stage is edited, it changes every instance connected to the original symbol in the Library. Break apart symbols on Stage using the *Break Apart* command to separate them from the original symbol.

5. Symbols can be saved to shared libraries. The objects in shared libraries can be used from multiple libraries and in many different movies.

13 Using the Drawing Tools

The drawing tools in Flash are the most important tools for creating character animations. A graphics tablet will make learning to use these tools even simpler.

1. Keep in mind that line widths drawn with the Pencil Tool will not rescale when the objects that they are attached to are resized. This could cause overlapping problems when lines are used in areas where fills and lines are drawn in close proximity to each other.

2. Use only straight, smooth, or ink lines when drawing. Any lines other than basic line styles will cause the movie size to grow and could slow the playback speed.

3. When a pressure-sensitive graphics tablet is used with Flash, be sure to check the Use Pressure option on the toolbar just to the right of the Paintbrush Tool Brush Mode option.

4. The Bezier Pen Tool creates lines along a path with handle points that can be manipulated the same as any other Bezier-type tool. Click and drag using the Bezier Pen Tool to create curved shapes.

5. To erase all elements drawn on the Stage, double-click the Eraser Tool in the toolbar.

6. To add a stroke to an object once it has been drawn, select the line size and line shape in the Stroke panel, click the fill color of the shape, and then click directly on the shape to add the stroke.

7. If an object's line is too rough, use the Smooth or Straighten options on the toolbar.

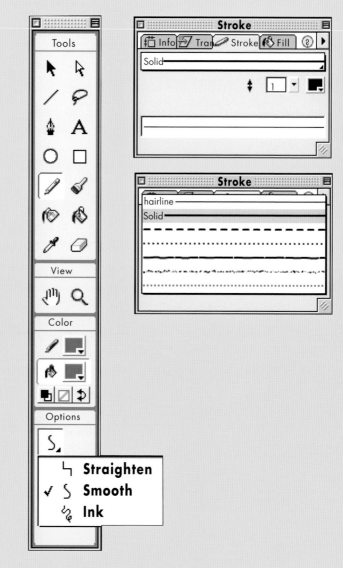

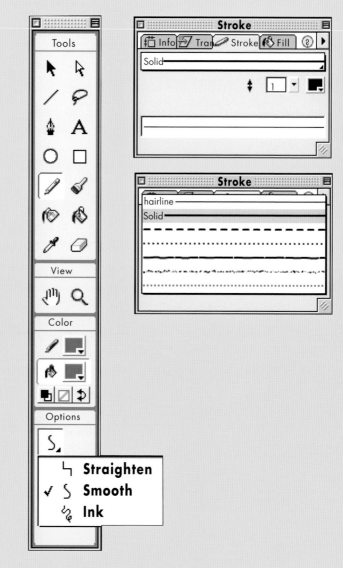
┗ **Straighten**
✓ ∫ **Smooth**
⌇ **Ink**

14 Using Colors and Gradients

Gradients are one of the more powerful color elements that can be used within Flash. The Gradient panel in Flash is similar to the gradient palette in Adobe Illustrator, which makes using it easier if you're familiar with the Illustrator application.

1. Choose the Gradient panel from the Panels menu. From the pull-down menu, select a Linear or Radial gradient.

2. Once a gradient has been selected, two gradient range points appar with small arrows at the top of the icons. Clicking on an icon highlights the color chip; clicking on the color chip allows the user to select a new color for the specific gradient range.

3. Clicking just below the gradient adds additional gradient range icons. Up to eight can be placed on the bar at one time, with each gradient range sporting its own color chip within the gradient.

4. Once a gradient color has been added to an object, clicking on the gradient modifier at the bottom of the toolbar places the gradient modification points on the object. The gradient modification points allow the user to rotate, stretch, and reposition a gradient within the object.

5. Be aware that using even small amounts of gradients can cause the file size of a movie to increase. Use gradients sparingly when designing and drawing in Flash.

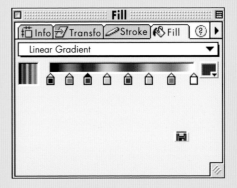

< resources >

< glossary >

Actions
Actions make a movie respond to events in particular ways. This makes a movie interactive.

ActionScript
Flash object-oriented programming language. Use ActionScripts to add interactivity to specific events.

Animation
The process of taking a series of static pictures–called frames or panels–and stringing them together in a timed sequence giving the appearance of continuous motion. Flash offers two forms of animation, tweened animation and frame-by-frame animation.

Antialiasing
A graphic technique used to blur and smooth diagonal edges and abrupt color changes along the edge of a graphic or piece of text.

Bandwidth
The data-carrying capacity of a data communications channel, such as within a cable, DSL, or modem connection.

Bandwidth Profiler
Allows the user to view downloading performance in a .SWF file. Use the Bandwidth Profiler in the Flash Player to see how much data is sent for each frame in the movie.

Bezier curve
To create curved segments using the Subselect Tool. Slope and length of each curve can be changed using anchor points and handles.

Bitmap graphic
A graphic image that is composed of a pattern of dots or pixels. The individual pixels are stored as data on a computer.

Browser
The software tools the user runs to view Internet pages.

Character panel
Used to edit the font's size, color, kerning, and leading.

Checkbox
Turns on and off the designated setting. When checked, the setting is on, and when unchecked, the setting is off.

Close icon or Close box
Lets you close the dialog box, window, panel, or application currently showing.

Controller
A floating dialog box that controls playback. Includes Stop, Rewind, Step Back, Play, Step Forward, and Go To End.

Custom keys
Customized Shortcuts for Flash commands and functions.

Dithering
Simulating a color by placing pixels in close proximity to each other.

Drop-down list
Displays an expanded hierarchical list of options that complements the selection. A highlighted triangle pointing down indicates a drop-down list.

Effect panel
Used to create color tints and transparency effects for vector graphics.

Event sound
A sound file that must download completely before it begins playing and that continues playing until prompted to stop.

External image editor
A program that you use outside the Flash environment to modify images.

Fill
A solid shape. Can be accompanied by a stroke.

Fill panel
Use to select a fill color and design linear and radial gradients.

< glossary >

.FLA file
The native Flash file format; the format you use to save your work when creating and editing a movie.

Flash lessons
Part of the instructional media provided by Macromedia with Flash. Interactive lessons that allow users to practice on examples that introduce you to Flash's core features. Can be found under Help menu.

Flash player format (SWF)
The main file format for distributing Flash content.

Flip
The act of turning an object over across its horizontal or vertical axis without moving its relative position on the Stage.

Frame
A single complete graphic image that is displayed chronologically in the Timeline. A single frame makes up a static image, while a series of frames make up an animation.

Frame-by-frame animation
Animation created using an individual image for each frame.

Frame panel
Used to set motion and shape tweens and their properties. Also used to label frames.

Frame rate
The number of animation frames to be displayed every second, usually expressed as fps, or frames per second.

GIF (Graphics Interchange Format)
A compression graphics file format developed by CompuServe and characterized by small file sizes and a maximum palette of 256 colors.

GIF animation
An animation that is created or exported as a GIF image.

Gradient
A transition from one color to another so that the intervening colors shade from the starting point to the ending point.

Grid
Lines that appear behind the artwork, allowing the user to position objects precisely.

Group
Two or more drawing objects combined so that you can edit or move them as a single unit.

Guide layer
Assists in holding objects that aid as reference points for placing and aligning objects on the Stage.

HTML (HyperText Markup Language)
The most popular coding method for defining documents on the World Wide Web.

Info panel
Used to edit an objects' size and location, as well as to check registration points.

Instance
An occurrence of a Flash element. When a symbol is placed on the Stage, an instance of that symbol is created.

Instance panel
Used to recall information about symbols and instances in your movie.

JPEG (Joint Photographic Experts Group)
A graphic file type featuring adjustable compression and the ability to display millions of colors.

Kerning
Adjusts the spacing between pairs of letters.

Key Frame
A frame in an animation that marks a key point of change or action.

< glossary >

Layer
A level or plane where a graphic or graphics can reside.

Library
Where symbols and imported files are stored.

Linear gradient
A gradient that follows a straight line.

Magic wand
A tool used to select groups of pixels in a bitmapped image based on a color or range of colors.

Mask layer
This layer hides and exposes sections of the linked layer that lies directly below.

Modifier
Additional actions of tools on the toolbar. For example, when you draw a rectangle using the Rectangle Tool, you can select the rectangle, and the modifiers for Smoothing, Straightening, Rotating, and Scaling become available.

Motion Guide Layer
Allows you to create a path on which an animation occurs.

Motion path
A drawn path that an animated object follows.

Motion tween
Tweening that changes position, size, rotation, skew, color, and tint of images.

Mouse event
Any movement of the mouse button, possibly triggering a mouse action such as clicking or rollover.

Mouse event actions
Actions assigned to a button that react to a mouse event such as a rollover.

Movie clip
A symbol selection used in Flash to describe an animated element.

Onion skinning
A preview mode that allows you to select a frame and then see the contents of surrounding frames in a dimmed, wire-frame mode.

Pixel
A small rectangle filled with color, referred to as a dot—as in dots per inch or dpi.

Playhead
The red controller bar that moves through the Timeline showing the current frame displayed on the Stage.

.PNG (Portable Network Graphics)
A graphic file format that supports transparency in Flash.

Projector or Standalone Projector
Software that allows a movie to be played without using the Flash Player software.

Publish
Creates a Flash Player file (SWF) and an HTML document that puts the Flash Player file into a browser window

QuickTime
A digital video-and-audio standard developed by Apple and popular for Internet use.

Radial gradient
A gradient that changes from the center of a circle and finishes at the circle's outer edge.

Rich media
Term describing advanced technology used in graphic design, going beyond static images or animated GIFs.

Rollover
An area on a Web page that triggers an event when the user moves the cursor over it.

Scene
Used to organize a movie's subject matter.

< glossary >

Shape tween
Creates an effect similar to morphing, making one shape appear to change into another shape over a fixed period of time.

Shared Library
Used to link to Library items as external assets. You can create font symbols to include in shared libraries, as well as buttons, graphics, movie clips, and sounds.

Shockwave
An animation and authoring file type established by Macromedia. Shockwave differs from Flash in that bitmap images are used instead of vector graphics, making Shockwave better suited to those with fast Internet connections.

Stage
The blank rectangular area where movies are created and played.

Streaming
The flow of data from a server to the visitor's own computer. Streaming allows for an animation to start right away while the rest of the file downloads in the background.

Symbol
A graphic with a series of instructions that can be duplicated, modified, and reused to help keep file sizes small and more easily editable throughout a file or files.

Text box
The bounding box that surrounds created or selected text, allowing the user to manipulate the type using the handle on the box.

Timeline
The area that holds each frame, layer, and scene that makes up the movie.

Transparency
An image attribute that allows one color to be transparent, showing underlying layers or objects.

Tweening
In tweened animation, a beginning and ending key frame is created and Flash fills in the in-between frames. The beginning key frame and ending key frame contain a significant event.

< resources >

About: Animation
http://animation.about.com

ActionScripts.org
www.actionscripts.org

A List Apart
www.alistapart.com

Altermind
www.altermind.org/v6tutorials.htm

Arabic typography
www.arabictypography.com/flash.html

Art's Web Site
www.artswebsite.co

Beatnik
www.beatnik.com

Best german Sites
http://bestflashsites.de

BrainJar
www.brainjar.com

Brendan Dawes' Headshop
www.brendandawes.com/headshop

Canfield Studios
http://canfieldstudios.com/flash4

Computer Arts Tutorials
www.computerarts.co.uk/tutorials

Concept 4 Web
www.concept4web.com

Crazy Raven
www.crazyraven.com

D-art
www.d-art.ch

Deconcept
www.deconcept.com

Designer Wiz
www.designerwiz.com

Digital Web Magazine
www.digital-web.com

Echo Echo
www.echoecho.com/flash.htm

EgoMedia
www.egomedia.com

Extreme Flash
www.extremeflash.com

Extreme Zone
www.extremezone.com/~pzero/en/home.html

Fig Leaf
http://chattyfig.figleaf.com

Flahoo
www.flahoo.com

Flash 4 All
www.flash4all.de

Flash 5 ActionScript!
www.flash5actionscript.com

Flash Academy
www.enetserve.com/tutorials/

Flash Central
www.flashcentral.com

< resources >

Flash CFM
www.flashcfm.com

Flash Challenge
www.flashchallenge.com

Flash Core
www.flashcore.com

Flash DB
www.kessels.com/FlashDB/

Flash deConstruction
www.juxtinteractive.com/deconstruction/

Flash Enabled
www.flashenabled.com

Flasher
www.flasher.ru

Flasher l
www.chinwag.com/flasher

Flash Factory
www.flash-factory.ch

Flash Film Maker
www.flashfilmmaker.com

Flash Forge
www.goldshell.com/flashforge

Flash Freaks
www.flashfreaks.nl

Flash Fruit
www.flashfruit.com

Flash Geek
www.flashgeek.com

Flash Gen
www.flashgen.com

Flash Guru
www.flashguru.co.uk/

Flash Heaven
www.flashheaven.de/englisch.htm

Flash House
www.flashhouse.net

Flash Jester
www.flashjester.com

Flash Links
www.flashlinks.de

Flash Lite
www.flashlite.net

Flash Magazine
www.flashmagazine.com

Flash Move
www.flashmove.com

Flash online studeren
www.sip.be/flash

Flash Opensource
www.fortunecity.com

Flash Planet
www.flashplanet.com

Flash Pro: The Netherlands
www.flashpro.nl

Flash Skills
www.flashskills.com

< resources >

Flash Tek
www.flashtek.com

Flash Thief
www.flashthief.com

Flash Xpress
www.flashxpress.net

Full Screen
www.fullscreen.com

Geckoarts
www.geckoarts.com/

Geomagnet
www.geomagnet.com

Help4Flash
www.help4flash.com

Intuitiv Media
www.intuitivmedia.com

killersound
www.killersound.com

Kilowatt Design
www.kilowattdesign.com

Kirupa Flash Tutorials
www.kirupa.com

Moock
http://moock.org

Motion Culture
www.motionculture.org

Nuthing But Flash
http://nuthing.com

Open SWF
www.openswf.org/

Philter's Flash
http://philterdesign.com

Photoshop Web guide
www.photoguide.co.za/flash/

Pro Flasher
www.proflasher.com

Quintus
www.come.to/qfi

Quintus Flash Usability
www.quintus.org/use

Screen Weaver
http://screenweaver.com

Shock Fusion
www.shockfusion.com

Site Point
www.sitepoint.com

Sticky Sauce
www.stickysauce.com

Stylus Inc.
www.stylusinc.com/website/flash_sql.htm

SWF Studio
www.northcode.com

Swiff Tools
www.swifftools.com

Swift Tools
www.swift-tools.com

< resources >

Swift 3D
www.swift3d.com

Swifty Utilities
http://buraks.com/swifty

Swish
http://swishzone.com

The Linkz
www.thelinkz.com

Training Tools
www.trainingtools.com

Tree City
www.treecity.co.uk

Ultra Shock
www.ultrashock.com

Vecta 3D
www.ideaworks3d.com

Virtual-FX
www.virtual-fx.net

Digital Animator
www.animator.com

E.N.Z.O.
www.enzo.co.kr

Het Grafisch Weekblad
www.gw.nl/

How Now
www.howdesign.com

IDN World
www.idnworld.com

NeoMu
www.neomu.com

Ningen
www.ningen.com

MAGAZINES

Computer Arts
www.computerarts.co.uk

Create Online
www.createonline.co.uk

Critique magazine
www.critiquemag.com

< directory >

Aspen Marketing Services
205 N. 10th Street, Suite 400
Boise, ID 83702
208-342-6403
www.aspenmarketingservices.com
rnielson@aspen-marketing.com

Cotaco Studio
1473 Calle San Rafael, Pda. 20
San Huan, P.R. 00909
787-949-2163
www.cotaco.com
carmenolmo@cotaco.com

Frontera Design
142 West 2nd Street, Suite D
Chico, California 95928
530-342-9953
www.fronteradesign.com
patrick@fronteradesign.com

Hendri Soerianto
Dragon Mansion Blk. 14
Spottiswoode Park Road #03-15
Singapore
+65-9620-1914
www.soerianto.net
hendri@soerianto.net

In Your Face New Media Design
142 West 2nd Street, Suite C1
Chico, California 95928
530-899-3223
www.inyourface.com
daniel@inyourface.com

Lookandfeel New Media
106 W. 14th Street, Suite 1400
Kansas City, MO 64105
816-472-7999
www.lookandfeel.com
info@lookandfeel.com

Popsicleriot
1355 Hayes Street
San Francisco, California 94117
415-609-4373
www.popsicleriot.com
dave@popsicleriot.com

Short Web Design
P.O. Box 180
Durham, California 95938
530-345-4224
http://homepage.mac.com/carolynshort/
carolynrae@aol.com

Daniel Donnelly is the owner of In Your Face New Media Design, a design studio located in Chico, California. He is also a multimedia instructor for Butte Community College. Daniel has written and designed eight multimedia and Web design books for Rockport Publishers.

www.inyourface.com